CREATIVE Lettering WORKSHOP

COMBINING ART WITH QUOTES IN MIXED MEDIA

LESLEY RILEY

NORTH LIGHT BOOKS
CINCINNATI, OH
CREATEMIXEDMEDIA.COM

CONTENTS

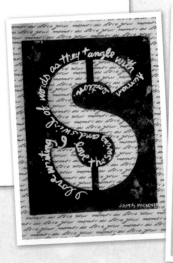

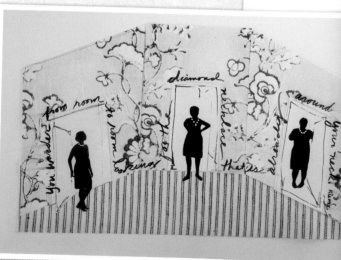

I have often walked myself into my best thoughts. Thoreau

There is no greater agony than bearing an untold story inside.

— Maya Angelou

START WITH A QUOTE OR START WITH ART

Unless created as freestanding works, quotations resemble found art The presenter of found art, whether material or verbal, has become a sort of artist. He has not made the object, but he has made it as art.

—Gary Saul Morson

Hello, fellow quote and art lover! I am so excited to be bringing this book to you. After putting together *Inspirational Quotes Illustrated*, I asked my editor if she was interested in my idea for this book. I wanted to continue my love affair with quotes and explore the process of adding lettering, specifically quotes, to art. My hope is that what you hold in your hands will guide and encourage you to experience the power of quotes + art.

There is no question that people, especially creative ones like you and me, find quotes to be inspiring and motivating. Quotes offer a limitless source of ideas. They awaken, guide, encourage and remind us of what is truly important in life. My love affair with quotes began in my teens. Fast forward a few decades to the year 1999 when I first began using quotes in my art. I created small collages, using photos and fabric to illustrate my favorite quotes. Since then, I've created over one thousand of these quote-inspired artworks. I call these works *Fragments.*

What I learned by making these works of art is how a quote can take on a whole different meaning and context depending on the colors, textures, art elements, font, materials and the image or focal point you choose.

The reverse is also true. Your artwork can tell many different stories depending on which quote you choose to go with it. Abstract art can impart as much expression and meaning as realistic and literal interpretations when paired with a quote. There is no best or right way to illustrate a quote. Your interpretation of the quote is always as important and meaningful as the quote itself.

You can take your inspiration from the art, the quote or the tools and materials you use to create it. Sometimes a new stencil, a paint color or a tempting new technique I just discovered will be my spark of inspiration, and I'll go searching for a quote, one of my all-time favorite activities. I look for one that inspires me and use my favorite art tools to translate my feelings, ideas, impressions and thoughts into art that matches or enhances the mood, meaning or message. What thrills me is how the final effect of quote + art is always greater than the sum of its parts.

Quotes
. . . express what we know, feel, believe, hope and desire.
. . . are easy to remember because they are impactful.
. . . put into words what we can find difficult to express.
. . . confirm or reinforce our own thoughts and ideas.
. . . best of all, positively impact (and even change) our outlook and our lives.

My goal and intention for this book is to share with you a variety of techniques and ideas to get you excited about adding quotes to your art as a means of self-expression. The methods I will share here range from super easy—your handwriting and stamping—to the more skilled, like hand-lettering. I will show you methods that guarantee success, even it's your first time.

Start where you are. It is more important to express yourself and successfully integrate the quote with the art than to create perfect art or lettering. Art and words should work together to create a balanced and integrated piece. The focus here is EXPRESSION.

MATERIALS USED IN THIS BOOK

Many of the items you can use to letter your quotes are probably already in your stash or can be substituted with something you already own and use. I use the tools and surfaces I recommend because they make life and lettering so much easier or are really essential to successful lettering. There are pens and such on the list that all serve the same purpose but have a different look or result. Artists like options, don't we?

I own and have used everything on these lists; you can certainly do wonderful lettering with a minimum of supplies.

Assorted pens: Pigma Micron, Pitt, Zig Marker, Pilot Parallel, brush pens, paint pens, nib pen, Signo Uni-Ball, Zig Cocoiro

Pens, Pencils, Brushes and Markers

Acrylic round brush
Akashiya Sai Watercolor Brush Pens
Chalk pencil, white
Colored pencils
Dip pen/nib holder plus nib (Speedball makes a nice intro set)
Pencil, or mechanical pencil, HB, 4H or no. 2
Pencil sharpener
Pilot Parallel Pen (I prefer the 2.4mm)
Pitt Artist Pens (waterproof, permanent)
Sakura Pigma Micron Graphic Pens
Sharpie Fine-Point Markers, metallic and assorted colors
Signo Uni-Ball white pen (UM-153)
Stabilo Aquarellable (Marks All) Pencil
White wax crayon

Watercolor Brush Pens/Markers

Water brush (Pentel Aquash Brush)
Watercolor pencils

Paints, Inks and Mediums

Acrylic inks: permanent or water-soluble
Acrylic matte medium
Acrylic paint: craft paint, fluid acrylics, Golden
High Flow acrylics
Alcohol inks
India ink
Liquid frisket
Opaque white watercolor (Dr. Ph. Martin's Bleed Proof White)
Pam Carriker's Derivan Liquid Pencil
PanPastels
Stamp pad inks, pigment (StazOn)
Tar gel medium
Watercolors

Sign up for our free newsletter at CreateMixedMedia.com.

Stamps, Stencils, Die-Cuts and Transfers

Alphabet metal stamps
Alphabet rubber stamps
Alphabet stencils
Alphabet stickers
Die-cut letters
Ink-jet transparencies
Quote stencils
Reverse alphabet stamps
Soft gel medium
TAP Transfer Artist Paper (plus iron and
ironing surface)

Watercolor brush pens (Akashiya Sai set)

Graphite transfer paper, ink-jet transparency (preprinted), soft gel medium, spoon burnisher, die-cut letters, sticker letters, rub-on letters, TAP Transfer Artist Paper, iron

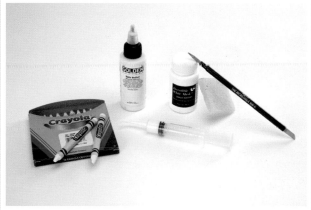

White wax crayons, matte medium, liquid frisket, frisket nib, curved-tip syringe

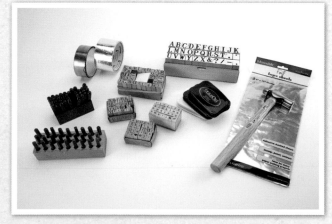

Metal lettering stamps, foil tape, rubber alphabet stamps, pigment ink pad, hammer, foil tape sheets

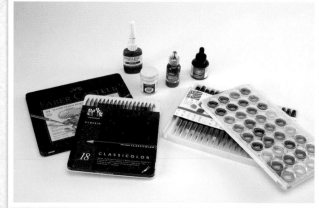

Water-soluble colored pencils, Fineline applicator with India ink, opaque white watercolor, Liquid Pencil, acrylic ink, watercolor brush pens, watercolors

For additional downloads from the book, go to: CreateMixedMedia.com/creativeletteringworkshop.

7

Surfaces

(In addition to this list, consider any paper or surface that is receptive to and retains the art materials you choose to use.)

Canvas panels or stretched canvases

Hot-pressed (smooth) watercolor paper

Kraft paper

Scrap paper

Scrapbook paper

Strathmore Mixed Media paper

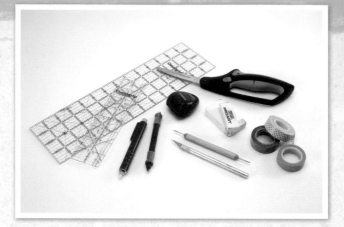

Rulers, scissors, chalk pencil, hole punch, pencil sharpener, erasers, Amaco burnishing tool, craft knife, washi tapes

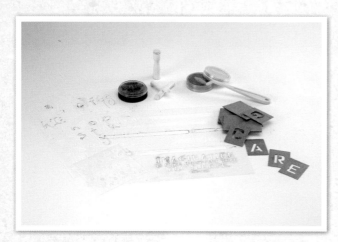

Lettering stencils and stamps, stamp ink, ink daubers, PanPastel, Soffit tool, letter stencils

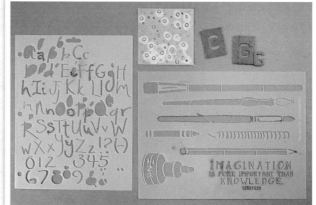

Assorted stencils

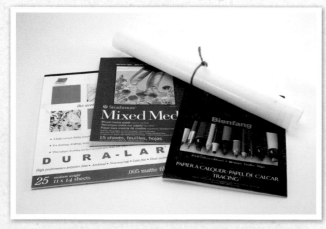

Art surfaces: Mylar paper, mixed-media paper, tracing paper, Lesley Riley's Mixed Media Mat

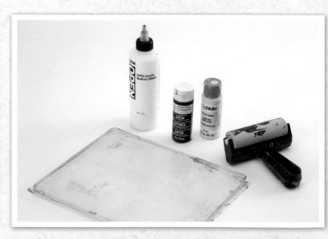

Gelli Printing Plate, Open Medium, acrylic paints, soft rubber brayer

Sign up for our free newsletter at CreateMixedMedia.com.

Additional Tools and Temptations

All-purpose glue

Computer and printer

Copper tape (hardware store, stained glass supply)

Craft knife

Curved-tip syringe

Decorative papers, assorted

Fineline Applicator (fine tip)

Gelli Plate and brayer

Golden Open Medium or Open Acrylics

Graphite or wax-free, erasable tracing paper, black and white

Hammer

Hole punch, small

Lesley Riley's Mixed Media Mat

Lightbox (or pad)

Low-tack tape: drafting, washi or painter's

Metal foil tape sheets (Ranger Inkssentials)

Plastic and rubber erasers

Rub-on transfer letters and burnishing tool

Ruler

Scissors

Soffit tool

Spray adhesive

Spoon

Stencil dauber

Workable and/or acrylic spray fixative

Assorted brushes: acrylic, watercolor, foam, waterbrushes

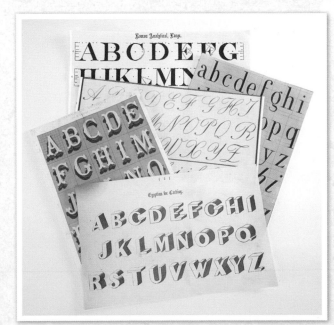

Reference alphabets

For additional downloads from the book, go to: CreateMixedMedia.com/creativeletteringworkshop.

9

PAY ATTENTION
TO WHAT YOU DO
SO YOU CAN
FIND OUT
WHO YOU
ARE.

MARY C. MORRISON

GETTING STARTED AND TYPES OF LETTERING

I always ask my students to start with an open heart and an open mind. To quote Henry Ford, "Whether you think you can or you can't, you're right." Thing is, you can do anything you set your mind to when you believe you can and the heart is willing. Most people give up way too soon. I'll help you over that hump in this section of the book as we explore overcoming fear, making a commitment to practice and become familiar with all of the lettering options available to us.

Fear is a natural by-product of growth, especially for artists. Bringing an idea or vision to life is always a courageous and vulnerable act. Yet millions are driven to do what they love and come face-to-face with their fear every day. The only way to get over fear is to take action on the thing that scares you.

I'll let you in on a secret. Writing this book scared me, but I have enough fear-conquering experience to know that the scariest part was the thought of doing it. The action of doing it dispelled all my fears. I am much happier and confident working through fear than I am worrying about it. You will be, too.

> *He who is not every day conquering some*
> *fear has not learned the secret of life.*
>
> **—Ralph Waldo Emerson**

> *Many of our fears are tissue-paper-thin,*
> *and a single courageous step would*
> *carry us clear through them.*
>
> **—Brendan Francis**

> *When the artist trusts her sensibilities,*
> *her creativity and her hands, fear is banished.*
> *The real fear needs to be for the mediocre life.*
>
> **—Robert Genn**

> *If you aren't in over your head, how*
> *do you know how tall you are?*
>
> —T. S. Eliot

Taking the Leap

Taking a leap into something new is not always easy. Arlene Holtz, one of the artists who answered the call for art for my previous book, *Inspirational Quotes Illustrated*, shared her experience with me.

"My [assigned] quote, 'If you aren't in over your head, how do you know how tall you are?' (T. S. Eliot), turned out to be rather prophetic for me! I experienced some fear and doubt while coming up with an idea and the subsequent painting efforts I did. I felt over my head and worried that what I would come up with wouldn't be good enough for publication.

"In the end the quote itself really helped me get over the hurdle and just do it, regardless of whether it gets selected or not. At least now I have a better idea about 'how tall I am.' Thank you, T. S. Eliot and Lesley, for this lesson and opportunity to grow!"

"Someday is not a day of the week," says Denise Brennan-Nelson. Today is the day for you to take the leap into illustrating your favorite quotes.

Over My Head by Arlene Holtz

EXPECTATIONS • CONFIDENCE • PRACTICE • COMMITMENT

Every art project begins with expectations: You get an idea and create a plan and you want it to turn out the way you envision. That initial vision and your expectations are your biggest enemy. When it doesn't turn out the way you envision, your first reaction is that it's no good. Or worse, that you have no talent.

Art that doesn't turn out the way you wanted it to is not bad art. It's just different. It may even be better.

It's tempting to focus on the product instead of the process. Let the process guide you. Have the confidence to know that your hands, your heart and your intuition know a lot more than your qualitative, analytical, right-or-wrong left brain does. Adopt my mantra, "Right [brain] is right!"

The more you practice your art, the more intuitive and confident you will become and the more satisfied you will be with your art. If you are enjoying the process, then really, who cares how the product turns out? No matter how good an artist appears to be, she is always working toward being better.

Commitment separates the doers from the dreamers. Your commitment does not have to be an all-or-nothing proposition. Twenty minutes a day, even starting with twenty minutes twice a week, will have you well on your way to making art that will meet and eventually exceed your expectations.

Amateurs practice until they get it right, experts practice until they can't get it wrong.

—Faith Duck

Stretch Yourself

Athletes, dancers, yoga practitioners, musicians and more know the value of warming up and stretching themselves. It's the only way they can improve and maintain their skills.

Artists need to stretch and warm up, too. Not just physically (although that's recommended), but mentally. Stretch and reach for a new skill, a new style, a new way of doing something. Push yourself past what you are already good at or comfortable doing. Stretch yourself right into a new way of being and doing. Stretching yourself is the only way to increase your reach and bring you closer to what you want. To create your best art, make stretching a habit.

The difference between ordinary and extraordinary is that little extra.

—Jimmy Johnson

Practice doesn't make perfect. Practice reduces the imperfection.

—Toba Beta

10 WAYS TO GET GOOD

1. Know your tools, what to use when and where. Many problems are not your lack of experience but the writing tool or surface you are writing on or both!

2. Practice creates neural pathways and muscle memory. You can't help but get good if you practice.

3. Do warm-ups before lettering your quotes: Write large loopy letters; move your arms in wide circles, then small circles and finally, shake it out.

4. Approach your work with the right attitude. This is not your once-in-a-lifetime chance. It's only artful lettering; you can do it again—and again, and again and again. (Lucky YOU!)

5. Slow down. Art writing is not done at the speed of handwriting. If you see others going faster, it's because they have practiced more and have experience.

6. View any mistakes as design opportunities. There is rarely something you cannot fix with a little creativity or new point of view.

7. While adding text to your art, remember to relax your shoulders and breathe.

8. Mark with confidence. Hesitant marks detract from the work. A slightly imperfect bold mark will always look better than a hesitant one.

9. Be original. Your original mark is always better than a poor imitation of someone else's.

10. Always test your writing tool on a similar surface before putting it to your art. Always!

HAND-LETTERING OR HANDWRITING?

*It is better to fail in originality than
to succeed in imitation.*

—Herman Melville

Hand-lettering is hot right now. You see it everywhere, especially hand-lettered quotes. I had adored hand-lettering from afar before taking the time to get intimately acquainted. I am not an expert in hand-lettering, but I don't let that stop me. I am just like you, trying to express myself through image and word.

Hand-lettering works in a variety of situations. You can letter in a style that adds to and enhances the artwork and write in areas of the artwork where it may be hard to use other techniques.

Lettering a quote enables you to match the lettering style with the quote itself or the artwork it illustrates. This both enhances and adds to the idea and message in the quote. While that can also be done with computer fonts, the inconsistencies and mark of the maker (that's you!) add so much more to the completed work of art.

Hand-lettering should not be confused with handwriting. Lettering is the art of drawing letters, one stroke at a time. Emphasis is placed on size, spacing, balance, weight, proportion and contrast. Just like the use of design elements and principles in art, things can look "off" when they are not applied correctly to lettering. It helps if you forget that you are making a letter or a word and just focus on the line and shape. When lettering, you are drawing, not writing. You are making a letterform, a graphic element.

Lettering is also not calligraphy. Calligraphy is a relative of handwriting. It is pretty and practiced writing with a few specific rules attached.

The best way to learn creative lettering is to practice tracing over or copying the letterforms—permission granted! By tracing, you are getting a sense for the hand movements and training your hand-eye coordination and muscle memory. Print some vintage alphabets to practice with. Even the pros trace over their own lettering to improve and master the style. There are many hand-lettering books as well as reference guides available online (see Resources).

Once you begin to work with lettering you will find that a few things are common to most lettering styles. Practice and remember them and you'll be well on your way to loving your lettering. Once you know these basics, you will find that, like any art, the more attention you place on self-expression rather than technique, the more your own beautiful style will emerge over time. For now, trust yourself and let your eye guide you but keep in mind these fundamentals, lettered by Carl Holmes for his 1931 book, *ABC of Lettering.*

THE FAST, FUN AND EASY SECRETS TO SUCCESS

Use a chisel-pointed pen nib or marker tip, or a lettering brush or brush marker, and follow these guidelines for hand-lettering:

- Make all downward strokes heavy by adding more pressure to the nib.
- Make all upward and horizontal strokes thin by releasing pressure on the nib.
- Always place a thin or light stroke between two heavy strokes.
- If using a brush or brush marker, create wider strokes/lines by using more pressure.

bine skill and judgment will you develop a style. There is no "royal road." The forms and their relative proportions will dawn upon you only as you practice. Only test and trial will give an understanding of their possibilities and limitations.

¶ As the Roman forms are the only perfected ones the student should begin with these, advancing into less determined ground only when fortified with accomplishment. Optical illusions enforce certain rules. Cross bars must be above center **EE** or they appear to sag. Cross bar of A is usually placed to balance **A** the spaces. Round letters appear shorter and smaller than others unless curves run slightly over **NOON** common base and top lines. Angle letters A, W and V must also be extended at the points, and letters J and U are extended at the bottom. Letters are not the same **SQUARE** in width, nor **ALIKE** can they be spaced equal distances apart. Set rules fail to work because each job is different, and words vary. The space must be judged by the area of white **ADJUST** between the letters, not the distance along the guide lines. The general rule is that the letters should have a uniform distribution of black and white — vertical sides **IH** need air, round letters have to be **POOR** closer, angle letters may **WAVE** overlap. The eye must be trained to judge, and to make use of the optical illusions to the advantage of the finished work.

¶ The chisel pointed reed of early calligraphers, held vertically, automatically determined the thick and thin strokes of letter. In letters of thick and thin

The eye sees horizontal lines thicker and heavier than perpendicular lines of same weight.

Both lines are the same in length.

The construction of the eye makes it easier to see horizontally than perpendicularly.

This illusion complicates hand lettering.

The illusion of an incised letter is given by a third line.

11

For additional downloads from the book, go to: CreateMixedMedia.com/creativeletteringworkshop.

15

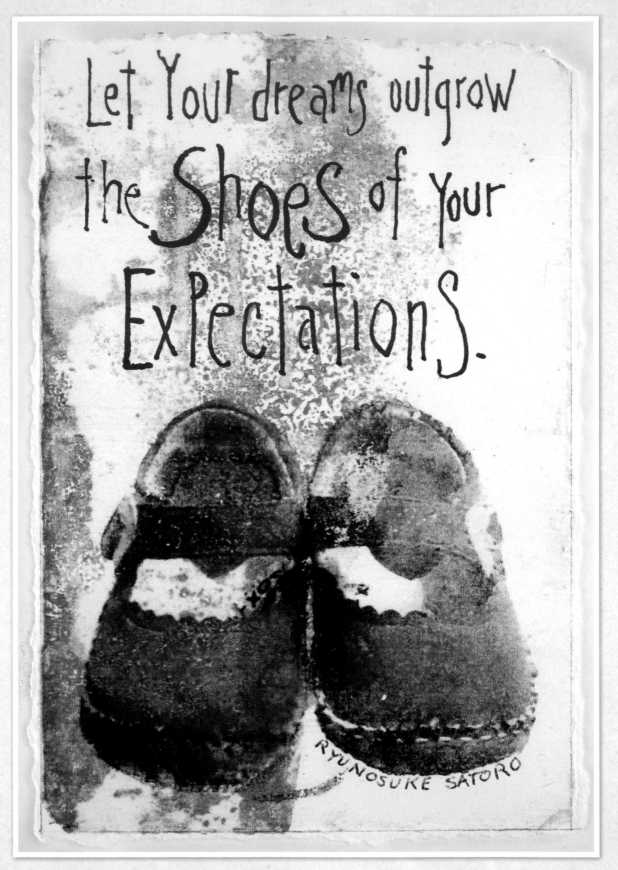

"Let your dreams outgrow the shoes of your expectations." —Ryunosuke Satoro
Lesley Riley
4" × 6" (10cm × 15cm)
TAP transfer and Cocoiro pen on painted watercolor paper

Sign up for our free newsletter at CreateMixedMedia.com.

QUOTE COPYRIGHT AND ATTRIBUTION

People are always asking me about the legality of copyright and using quotes in artwork. The legally correct answer is, it varies. The only valid determination of fair use would be decided in a courtroom, if your use of the quote ever got that far, and few ever do. Any legal action is highly unlikely if you are aware of and follow a few basic guidelines. Disclaimer: What I have to say is not legal advice but has been well researched over my fifteen years of using quotes in artwork, both privately and in work that has been published and sold.

Copyright and trademark laws were established to prevent other people from claiming ownership or creatorship and, most importantly, making money from another person's original work. Unless your actions make it appear that you claim to be the originator of the words you are quoting, or you are attempting to sell and/or commercially distribute work, like a poster or print, where the quote is a substantial or sole portion of the work, you are not legally likely to be considered infringing on copyright.

Three test questions to further determine fair use are to ask yourself:
1. Could the work exist without the quote?
2. Does my use of the quote leave the value or potential value of the quote unharmed?
3. Is the market for the quote as it will be used either absent or negligible?

If you can answer yes to these questions, it is most likely fair use.

Most importantly, always give proper attribution of the quote. When I know that artwork will be published, I have a rule of not using any quotes that I cannot correctly attribute or are considered anonymous or unknown. It still may be considered fair use, but I consider correct attribution a safety net, a courtesy and a way to say "thank you" to writers for sharing their wisdom.

MISATTRIBUTION— MORE COMMON THAN YOU THINK

One of the most misattributed quotes belongs to Marianne Williamson who says, "As honored as I would be had President Mandela quoted my words [in his 1994 inaugural address], indeed he did not. I have no idea where that story came from, but I am gratified that the paragraph has come to mean so much to so many people."

Our deepest fear is not that we are inadequate. Our deepest fear is that we are powerful beyond measure. It is our light, not our darkness, that most frightens us. We ask ourselves, Who am I to be brilliant, gorgeous, talented and fabulous? Actually, who are you not to be? You are a child of God. Your playing small does not serve the world. There is nothing enlightened about shrinking so that other people will not feel insecure around you. We are all meant to shine, as children do. We were born to make manifest the glory of God that is within us. It is not just in some of us; it is in everyone and as we let our own light shine, we unconsciously give others permission to do the same. As we are liberated from our own fear, our presence automatically liberates others.

HAND-LETTERING

Many hand-lettering styles can be done with a regular marker, pen or pencil. I like using a brush marker. The important thing is to choose a writing tool you are comfortable with. The better you know your tool, the more control you will have over the outcome. Just keep in mind, hand-lettering is not supposed to be perfect. You want that "made by hand" look in your lettering.

Different moods and messages can be created depending on whether you use a fine or broad nib, bright or neutral colors or colors drawn from the artwork, straight or slanted (italic) lettering. A few minutes (which may stretch to an hour or more) spent looking at fonts on any font website or Pinterest can inspire a variety of ways for you to letter your quotes by hand. Feel free to mix and match styles in the same quote, putting your spin on lettering styles.

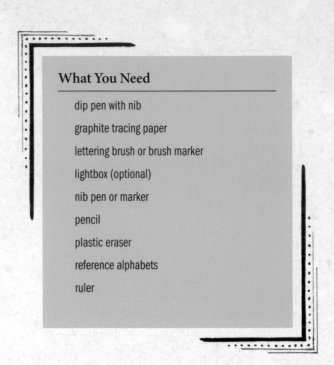

What You Need

dip pen with nib

graphite tracing paper

lettering brush or brush marker

lightbox (optional)

nib pen or marker

pencil

plastic eraser

reference alphabets

ruler

When

Depending on how you are creating your artwork, the lettering could come halfway through or at the very end. If it's a painting, I would recommend waiting until the end. With collage and mixed media, you may want to add it once you have figured out the placement.

Surface

Unless you like a rugged grungy look, hand-lettering should be done on a smooth surface. I prefer hot-pressed watercolor or mixed-media paper. Color and art can be added with watercolors, markers and thin layers of fluid paint or ink. Avoid paints and mediums that will leave a rough surface.

How

Sketch out the lettering of the quote on scrap paper with a pencil. Lightly draw the basic letter frame or skeleton of each letter. Flesh it out by adding thicker lines or embellishments. Adjust and refine spacing and letters as necessary.

With your artwork on the bottom, layer graphite tracing paper over the artwork (or use a lightbox) and place your lettered sheet on top. Trace the quote onto your artwork.

Once transferred to the artwork, use the pen or brush of your choice and trace over and/or color in the lettering on the artwork.

When you are more experienced, you can skip the tracing and go right to lightly lettering the quote directly on the artwork with a hard (2HB) pencil. Keep your eraser handy!

LETTER STRUCTURES

Fancy lettering is built on the framework or skeleton of a letter. An easy way to achieve a hand-lettered look is to write out your quote in basic sans serif letters and then go back in and add to each letter by outlining, thickening and adding swashes or decoration. The trick is to remain consistent, always adding to the same side or position on each letter or letters.

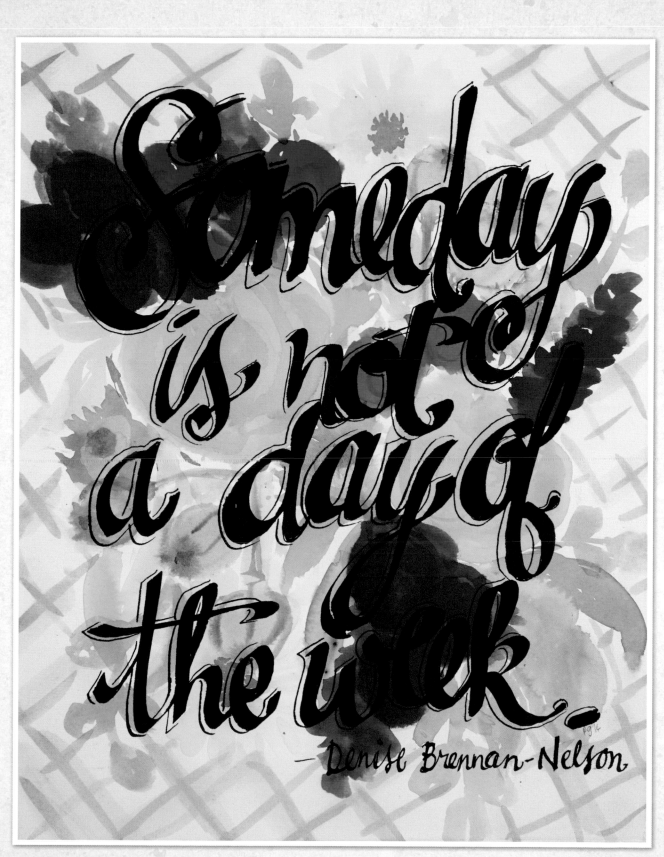

"Someday is not a day of the week." —Denise Brennan-Nelson
Pam Garrison
8" × 10" (20cm × 25cm)
Broad tip nib on painted watercolor paper

HANDWRITING

Using your own handwriting is the easiest and usually the fastest way to add a quote to your art. Your handwriting is unique to you, so what better way to add a quote to your art than in your own handwriting? What? You say you hate your handwriting?

There's handwriting, and there is artful handwriting. To make your handwriting likeable and art-worthy, the first thing you need to do is slow down. Your day-to-day handwriting is usually done rather quickly with no attention to design. If you take some time to focus on it you just may find that it's attractive. Slow down just enough for it to be beautiful, but not so slow that you hesitate or lose rhythm.

Look at the whimsical pencil writing Mindy Lacefield did on her piece on the opposite page and the very simple, yet powerful, printing Lynn Whipple used in the section The Elements of Design. Their handwritten style adds to and enhances the message of the quote and their artwork.

Using the right tool will also make a difference. I am very picky about the tools I use for everyday writing. They have to feel good in my hand and move well across the page. I prefer gel pens to ink and soft lead pencils to hard. When I am using the right tool, I enjoy the process and it shows in my writing. For your artwork, consider changing the writing tool you use to one that adds the artiness for you, like a chisel tip or a parallel pen. Above all, find a writing tool that is comfortable, flows well and brings you joy.

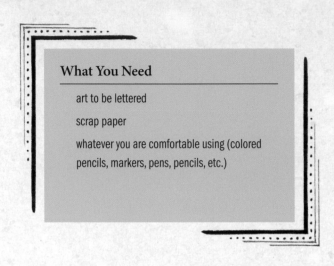

What You Need

art to be lettered

scrap paper

whatever you are comfortable using (colored pencils, markers, pens, pencils, etc.)

When
Add the quote when you get to the point in your artwork when you know where it will go or at the end.

Surface
Handwriting will work on almost any surface as long as you choose the right tool for the surface you are working on.

How
You know how to use your own handwriting, so there isn't much I can tell you. I do recommend that you warm up and practice writing the quote before you put pen to art. You need to know how much space you will need, especially if you plan to spread out your letters or add a lot of swash.

Write the quote, then embellish your handwriting. Go over individual letters to emphasize curves or crossbars. Here are a few more techniques I use to improve and elevate my everyday handwriting.

- Spread out your letters.
- Use irregular spacing between letters in a word.
- Make your letters long and lanky.
- Add generous swashes and flourishes.
- Revert to the "proper" formation of your letters. (You can download cursive practice sheets online.)
- Change the writing tool you use to one that adds the artiness for you, like a chisel tip or a parallel pen.

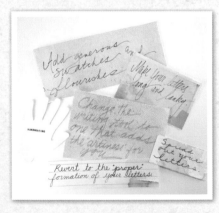

ALL TOO FAMILIAR
Because letters are such a familiar and integral part of our lives, we are accustomed to and comforted when they look a certain way. If your letters are too different or out of proportion from what we have come to expect, they may become illegible or off-putting to a reader.

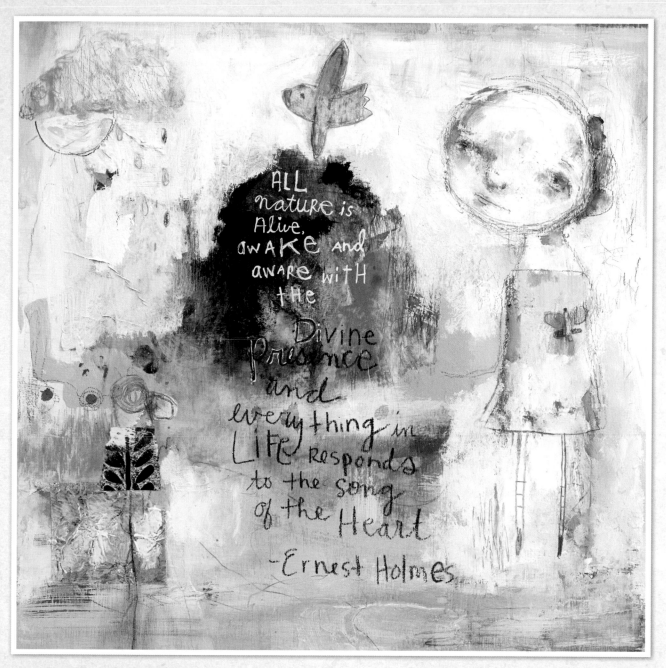

"All of nature is alive, awake and aware with the Divine presence, and every-
thing in life responds to the song of the heart." —Ernest Holmes
Nature Is Alive
Mindy Lacefield
12" × 12" (30cm × 30cm)
Acrylic paint, colored pencil, paper, gel pen, black pencil and oil pastel on wood

PERFECTLY ILLEGIBLE

Did I say slow down? Well, you can speed up, too. If being
totally legible isn't a necessity, you may want to try speeding
up your everyday handwriting. Let your words flow together and
your strokes whip around. This is art after all, and not everything
has to be perfect. The action of the fast handwriting might be
just the art element that ties the quote and art together.

Digital fonts and lettering are time-savers and take the worry and fear of mistakes out of hand-lettering, writing and stamping. The variety of available fonts adds another layer of design that works together with your quote and artwork to make an inspiring illustrated quote. I am a font junkie. I can't seem to get enough of them, especially the ones with a handwritten or hand-lettered look.

Many fonts are available for free or inexpensively from font websites and digital scrapbook websites. All have unrestricted personal use. Once downloaded and added to your computer's font folder, you have access to them in both your word-processing and photo-editing software and apps. Most likely you already have some fun and decorative fonts installed on your computer.

You can choose just the right font, from the standard Times New Roman and Helvetica to more exotic fonts such as DRANSKOF, boxybloxks or ROSEWOOD. The font becomes an element of design that adds to and incorporates seamlessly into your art and mirrors or complements the message of your quote.

Fonts differ widely in their size, spacing and their weight—how bold, fat or heavy they appear. All of the fonts below are in the same point size yet vary widely in size and impact as well as their message and significance.

Black Oak

Edwardian Script

Florence

VENEER

Wide Latin

When

Digitally generated quotes can be added from beginning to end depending on the art you create and the method you choose to incorporate the quote into your artwork.

What You Need

- computer
- decorative paper (optional)
- ink-jet-ready watercolor paper (optional)
- lightbox (optional)
- printer
- printer paper
- TAP Transfer Artist Paper or ink-jet transparency
- tracing paper, graphite and regular
- word-processing or photo-editing software, either with a variety of fonts

Surface

You can add digital fonts to a variety of surfaces using the different methods listed below.

How

Digital fonts can be used in a variety of ways to illustrate quotes. Type out your quote in your desired layout in the font of your choice (or mix in two or three!) and:

- Print on copy paper and use a lightbox to trace it onto your art.
- Print on copy paper and use graphite paper to transfer it to your art.
- Print in reverse on TAP Transfer Artist Paper or a transparency and transfer it directly to your artwork.
- Print it onto decorative paper and collage it onto your art.
- Print your quote on ink-jet-ready watercolor paper and create your art around the quote. (Use a printer with pigment-based printer inks or an acrylic spray fixative on dye-based printer inks before adding art.)
- Incorporate digital fonts into your digital art or a photograph you are using to illustrate a quote.

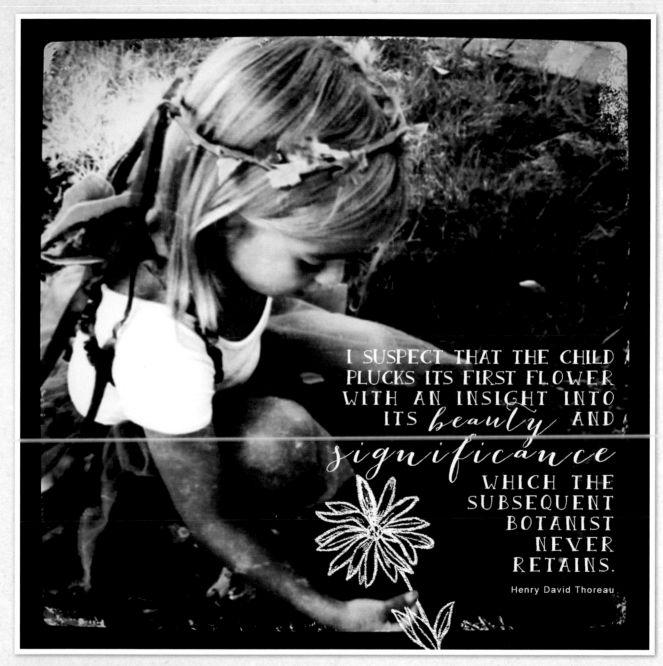

"I suspect that the child plucks its first flower with an insight into its beauty and significance which the subsequent botanist never retains." —Henry David Thoreau
Lesley Riley
5" × 5" (13cm × 13cm)
Digital lettering on digital photo
Photography by Annie Riley

RUB-ON, STICKER AND CLIPPED LETTERING

Stickers and rub-ons are not just for kids. We have sophisticated taste, artistic know-how and cutting-edge design skills and tools at our fingertips. Cutting out an entire quote, letter by letter, word by word, is one way, but that would be quite tedious. Here are several fast, fun and easier ways to individually add letters or complete words to art.

A favorite method for many is to type and print out the quote and then cut it out in its entirety, into several lines or each individual word. Printing onto hand-painted, decorative or vintage paper adds another element of design and helps incorporate it into the artwork. Cut words or lines can be used as art elements and arranged to add interest, add line and shape to the art, lead the viewer's eye and more.

It takes a bit longer, but searching for and clipping words of your quote out of old books adds an artistically vintage look to your final piece.

Enlarge and cut the capital letter of the first word of your quote out of decorative paper or paint it after cutting. This big (and usually embellished) letter is known as a drop cap and can set the tone and act as a bridge between art and word.

Die-cut alphabet dies come in a variety of sizes and fonts, making it easy to create a quote with individual letters. The smallest alphabet die I have found has letters that are ⅜" to ½" (10mm to 13mm), which will work to collage short quotes on average-size artwork or longer quotes on larger pieces. Consider proportions before you start cutting so you don't end up with a quote that overpowers your art.

There are a variety of fun and colorful alphabet stickers available for scrapbookers. Lettering a quote might take several sheets or packages, depending on how many vowels and popular letters you need. Head to the drafting section of your local store to find self-stick ¼" and ½" (6mm and 13mm) letters in sets with plenty of A,E,I,O,Us, L,M,N,O,Ps and R,S,Ts.

Before the age of computers, designers and artists used rub-on transfer letters for all of their lettering needs. Rub-on transfers are popular with scrapbookers, but letter sheets, which were popular and plentiful before computers, are a bit harder to find now. Rub-on transfer letters work on a variety of surfaces, including rough ones. Rub-on letters (with plenty of vowels) come on a clear sheet, making it easy to line up your lettering.

What You Need

alphabet stickers (optional)

die-cut machine (optional)

glue (all-purpose) or gel medium

old books

painted, decorative, vintage or recycled paper

paper-backed fabric

rub-on letter sheet and burnisher (a craft stick will work)

tweezers (optional)

When

Cutting and pasting a quote and using rub-on or sticker lettering is a collage process and can be added at any point of your artmaking. A quote is a major design element, so take care in how you incorporate it into your art. (Don't just stick it down anywhere.)

Surface

You can add cut-and-paste, rub-on or sticker words and letters onto any surface.

How

Sticker letters are designed to stick onto most surfaces. When in doubt, use glue or medium for permanent adhesion.

Apply rub-on letters with the burnisher in the package or use a firm tool with a round point to burnish letters, one by one, onto your art.

Text or letters that have been die-cut or cut out by hand are easily applied with glue. I prefer Elmer's glue, but any glue, including gel medium, will work. In some cases, it may also be helpful to use tweezers to assist in placement onto the artwork.

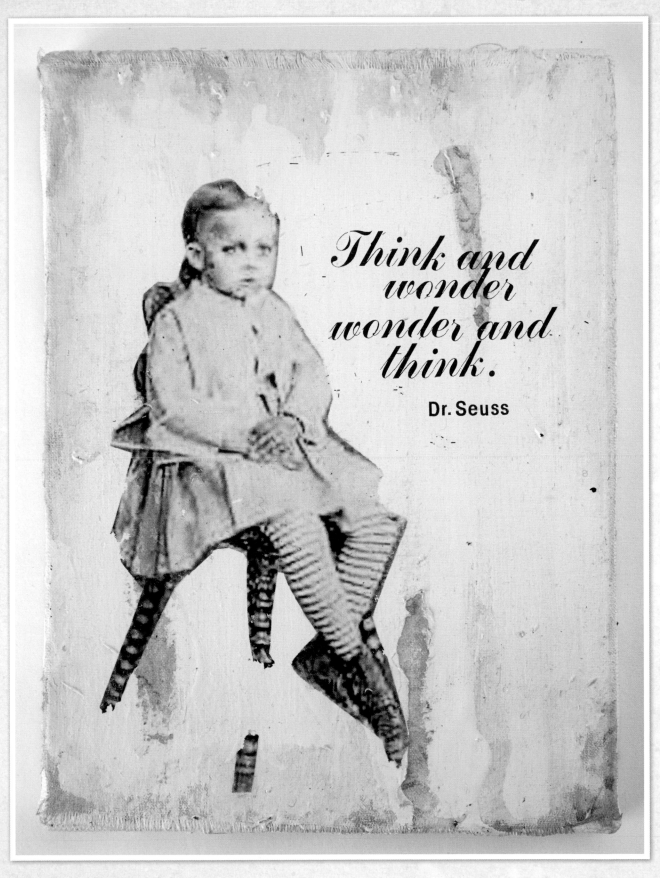

"Think and wonder, wonder and think." —Dr. Seuss
Lesley Riley
5" × 7" (13cm × 18cm)
Rub-on lettering on painted canvas with transfer

For additional downloads from the book, go to: CreateMixedMedia.com/creativeletteringworkshop.

25

RESIST LETTERING

A resist is any material that blocks and prevents paint or ink from adhering to the area covered by the resist. It is a fun way to apply lettering because you don't know exactly what it will look like until the big reveal, the addition of a layer of paint. Applying masking tapes, removable stickers, wax or mediums that seal the paper surface and prevent paint absorption creates a resist. For detail work such as lettering, I recommend my two favorite methods: Liquid frisket and acrylic mediums.

Masking fluid or frisket is a liquid rubber applied to the paper prior to painting and removed after the paint has dried. Fine details and lettering can be masked with a brush or a tool created specifically for liquid frisket.

Acrylic mediums, such as tar gel and matte medium, are applied with a brush or through a curved-tipped syringe. I have more control and get thinner lines by using the syringe.

Acrylic resists are applied prior to painting but are not removed, and need to be dry before any paint is applied.

Depending on your method of application, acrylic mediums do not always block all of the paint from being absorbed, but they do limit the amount that can be absorbed and will create a contrast between the lettered areas and the surrounding painted areas. Lettering will remain somewhat raised after application. After applying paint over tar gel, wipe excess paint from the tar gel while still wet for best results.

Wax crayons and China markers create a barrier on the surface that will block the absorption of paint. Be sure to use extra pressure to lay down adequate wax when writing the quote with the crayon or marker.

When

Adding the resist to your art is usually the first thing you do unless you add a base color or pattern to the paper first, which, when subsequently masked by a resist, will become the design/color of your lettering.

What You Need

acrylic ink, fluid acrylic paint or watercolor

choice of resists—one or more optional: acrylic medium, alphabet stickers, China Marker, liquid frisket, masking fluid, tar gel or wax crayon

curved-tip syringe (optional)

small paintbrush or script brush (optional)

Surface

Resists will work on almost every surface. Be sure that the resist method and medium you choose will not be dissolved or worn away by the method or material you apply on top of the resist.

How

Determine the position and location of your quote. Write or letter the quote with the resist of your choice and let it dry.

Apply one or more layers of fluid acrylic paint, watercolor or acrylic ink over the resist. Once the final layer of paint is dry, remove the resist if applicable.

"I have often walked myself into my best thoughts." —Henry David Thoreau
Lesley Riley
9" × 12" (23cm × 30cm)
Gel medium resist and acrylic paint on mixed-media paper

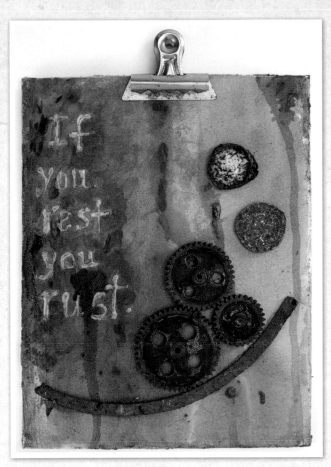

"If you rest you rust." —Helen Hayes
Lesley Riley
8" × 10" (20cm × 25cm)
Tar gel medium resist on painted and collaged canvas board

TRANSFER LETTERING

Transferring word and image from one surface to another has been a passion of mine for decades. There's just something so magical and, dare I say, addictive about it. Transfer-lettering results are surface and method-specific, meaning different methods work best in certain situations on specific art materials and surfaces. Some methods give an almost perfect result, while others create a grungy, worn effect. The thing about transfers is that they are not an exact science and results are not guaranteed. And that's what I love about them—their imperfection, beautiful flaws and wabi-sabi aesthetic.

As with digital fonts, transfers enable you to enhance your artwork by using a variety of fonts that would be difficult to hand-letter.

If you like the look of a preprinted quote but don't want to cut and paste it onto your art, a transfer may be the answer. Here I briefly share two tried-and-true transfer methods I have developed and use. You can find instructions for several transfer methods online and in books.

What You Need

gel medium (I prefer Golden Soft Gel Medium because it is easier to spread thinly and evenly)

ink-jet transparencies

spoon

or

iron and ironing surface

TAP Transfer Artist Paper

When

Quotes can be transferred to your artwork at any point in the process, but keep in mind that the acrylic or polymer that enables the transfer will seal the area underneath the transfer and will also limit the art materials you can use on top of the transfer.

TAP Transfer Artist Paper works best on an absorbent surface, so it's not recommended for use on acrylic painted surfaces, which can melt and bubble when heated.

Surface

All transfer methods work best on smooth surfaces because the paper or transparency that the quote is printed on needs to come into complete contact with the receiving surface in order for all the details to transfer completely. Even then, perfection is not guaranteed (or desired!).

How

Decide on the size, font and positioning for your quote. Print your quote in reverse either onto TAP Transfer Artist Paper or an ink-jet transparency.

For TAP transfers, follow the package instructions and iron the quote onto your art. Peel while hot.

For transparency transfers, brush a thin layer of soft gel medium onto the area of your art where you will transfer the quote. It should be slick, but not overly thick or wet, and not too tacky. I like to run my finger over the gel to smooth it out and test for the evenness and the amount of the soft gel application.

Place the quote printed-side down onto your artwork and with some pressure, use your thumb in the bowl of the spoon and burnish the quote in a circular motion until it transfers. Peel immediately.

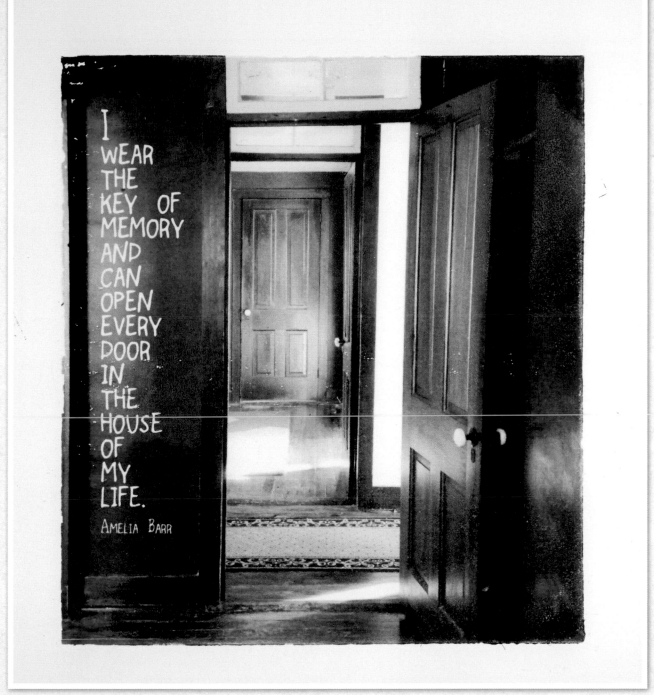

"I wear the key of memory and can open every door in the house of my life."
—Amelia Barr
Lesley Riley
6" × 7" (15cm × 18cm)
Text added to digital photo in Adobe Photoshop; transferred to watercolor paper
with TAP Transfer Artist Paper

GELLI PLATE LETTERING

Gelli Plates are becoming a standard tool in many art and craft studios. Why? Because they are so fun and easy to use. They are perfect for stencilling, masking, mark making and drawing onto the paint-covered surface and creating unique and often multilayered monoprints.

Like transfers, Gelli Plate printing is a reverse or mirror-image process. Whatever you put on the plate ends up in reverse on your finished print. This makes using text problematic. It's difficult to write a word backwards, much less a whole quote, before the paint dries, preventing you from making a good print. I tried using die-cut letters and stickers in reverse but kept ruining the paint on the plate when placing and removing the letters.

I was determined to combine my Gelli Plate and quotes. After searching for and not finding any stamps that could be used in reverse or mirror image, I created my own mounted reverse alphabet stamp set, so I (and you!) can always get a nice sharp print. The secret in lettering a quote on a Gelli Plate is to combine an extending medium with your paint so you have more working time. Golden has a line of open acrylic paints that are wonderful to use, as well as open medium, which you can combine with your own paints to extend the working time.

You can also use a white wax crayon and write the quote on your paper before printing the paper on the Gelli Plate. The wax will resist the paint on paper and reveal the written quote.

Once your quote is down, it is easy to paint, collage, draw and create art around it. The print made using reverse alphabet stamps will always be unique, one of a kind and, like transfers, perfectly imperfect.

When
Due to the nature of Gelli printing, the quote has to be placed on the artwork in the beginning stages or masked if continued prints are made.

Surface
Any flat smooth surface will work: Papers, journal pages, fabric, wood, etc..

What You Need

acrylic paints

brayer

Gelli Plate

Golden Open Medium or Open Acrylics (keeps paint from drying out while you stamp)

marker or pen to outline letters (optional)

mixed-media paper or smooth watercolor or printmaking paper

reverse alphabet stamps or computer

white, Gelli printed and/or patterned paper

white wax crayon

How
Stamping
Using reverse alphabet stamps or your computer, print your quote in reverse and in a similar size to your stamps to create your stamping guide.

Start with white or Gelli printed and/or patterned paper. Whatever color(s) you start with before adding the quote will be the color of the quote. The quote is usually the last print you make, but you can continue to print over the quote if you mask the quote or quote area on the plate.

Mix Open Medium with your paint in about a 1:4 ratio, right on the Gelli Plate and use a brayer to spread the paint on the plate. Refer to your reversed lettering guide and stamp the quote in reverse from right to left. If you make a mistake, just start over by brayering the paint, but don't let the paint dry!

Place your mixed-media or other paper down on the plate and gently burnish with a clean brayer or your hands to create your quote print. If desired, outline the letters to add more definition and embellishment.

Wax Pencil or Crayon Writing
Use a white wax crayon to write your quote, then make your print.

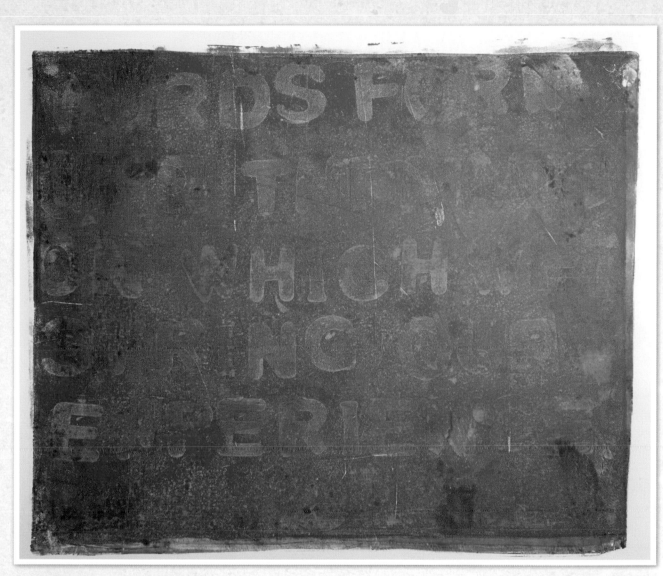

"Words form the threads on which we string our experiences." —Aldous Huxley
Lesley Riley
14" × 12" (36cm × 30cm)
Print created with reverse stamping onto Gelli plate

STAMP AND STENCIL LETTERING

Second to handwriting, stamping is the easiest way to letter a quote onto your art. Letter or alphabet stamps are easy to use and come in a variety of fonts and sizes. Keep size and proportion in mind, as well as the theme and feel of your quote, when choosing a stamp set. Foam letters are less expensive but are usually too large for lettering a quote on smaller artwork.

Metal stamps—for stamping onto metal and other surfaces that can hold an impression—can be found in limited sizes and are usually a sans serif font.

Lettering stencils, from the basic draftsman's lettering guide to designer alphabets, enable you to add quotes to your art in a variety of ways.

When
Stamping can be done at any point in your artmaking. Stencilled quotes are usually added after the artwork has been completed.

Surface
Papers, board, canvas, painted surfaces, metal foil and craft-weight metal sheet. Stencils can be used over every surface, even uneven ones.

How

Rubber and Foam Stamps
If size and positioning on your artwork matter, do a practice run of the quote on scrap or tracing paper. It also helps to prevent misspellings if you have a reference to work from. Ink your stamps with rubber stamp ink or a marker or acrylic paint, and apply to your art. Avoid using too much pressure when stamping so that the surrounding rubber mount will not leave a mark.

Metal Stamps
Metal stamp impressions are best done on a firm stamping surface. Use a large, well-balanced hammer to make the best impression in one strike.

Applying rubber stamp ink or paint to the letter on the metal stamp before stamping into metal will add color and definition to the letters. Alternatively, you can rub wetter inks, such as alcohol or acrylic ink, onto the stamped surface, allowing the inks to settle into the incised areas. Wipe

What You Need

- hammer
- ink pads, appropriate for the surface you stamp on (I prefer StazOn)
- lettering stencil
- metal alphabet stamps
- PanPastel and Soffit tool
- pen (fine-tip), pencil or markers
- rubber alphabet stamps
- rubber stamp ink, alcohol ink or acrylic ink or marker

away any excess from the surrounding areas as desired (see Project 1).

Stencils
Use the stencils to outline individual letters onto your art. You can take it a step further by adding color or graphic elements, such as dots, inside the lines.

Alternatively, skip the outlining and use the stencils with markers and colored pencils, stamp ink, acrylic paint or PanPastel using a brush or dauber if necessary to add color directly through the stencil to the art.

There are also stencils that have a complete quote ready for you to stencil, such as the Pen & Ink stencil I used in Project 9.

Place the stencil over the finished art and use one of the above methods to add color or outline each individual letter, building your quote letter by letter. You may find it helpful to do a practice run first to make sure it will fit where you want it to go.

Adding a baseline or guide will help keep your lines and letters straight, but straight isn't always the goal.

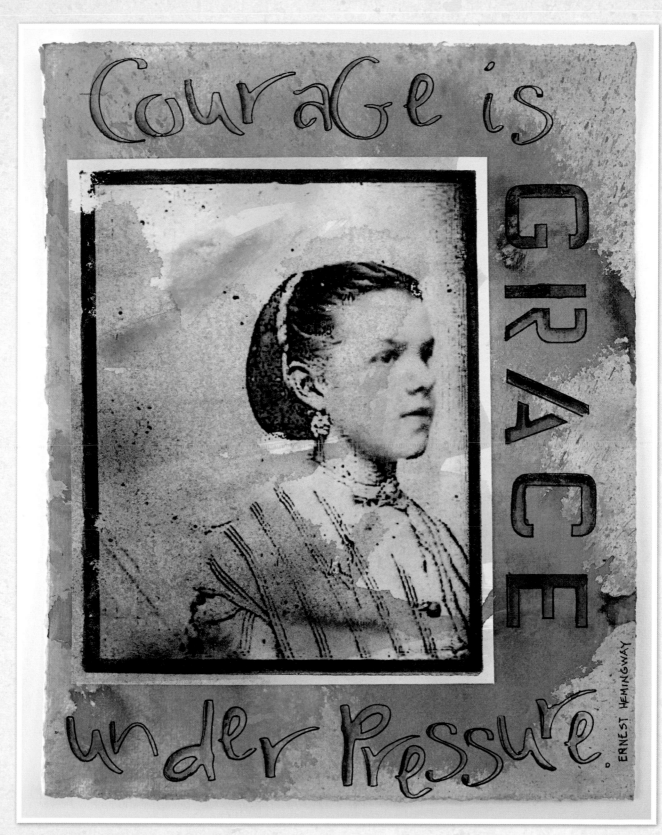

"Courage is grace under pressure." —Ernest Hemingway
Lesley Riley
7" × 9" (18cm × 23cm)
Stencil lettering with collaged TAP transferred image on painted watercolor paper

All of the lettering techniques I have shared in this section can be combined to letter your quotes. A hand-lettered word stands out in a sea of stamped words. A transferred phrase takes on new meaning surrounded by cut and pasted words.

Use your design skills to draw attention to a significant word or phrase in a quote by choosing a technique that makes it visually stand apart from the rest of the quote—think size, color, texture or materials.

There are no rules! The quote itself is a combination of art elements—line, shape, space and color—so apply the same artistic flair and design to the lettering as you do to the rest of your art.

"Open your eyes. Are you satisfied with the life you are living?" –Bob Marley
Eyes
Lesley Riley
6" × 6" (15cm × 15cm)
Stick-on letters were used as a resist prior to adding green paint, as well as cut-and-paste text printed on scrapbook paper (DecoArt Americana Writer)

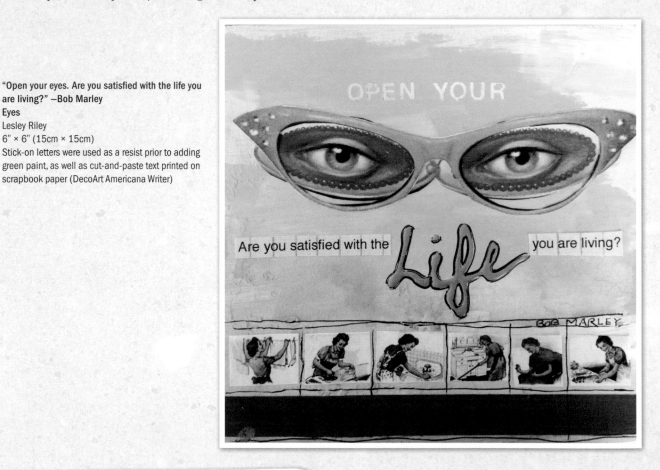

A WORD ABOUT LEGIBILITY

Creating art is a means of self-expression. I want the quotes I add to my art to be easily read. That is my style, my preference. But there is no rule anywhere that says that all or any of the words you add to your art have to be legible. Artfully lettered quotes can be done in both abstract and literal interpretations. One or a few illegible words can impart as much of your message as precisely quoting someone else can. Let your art and your style be your guide.

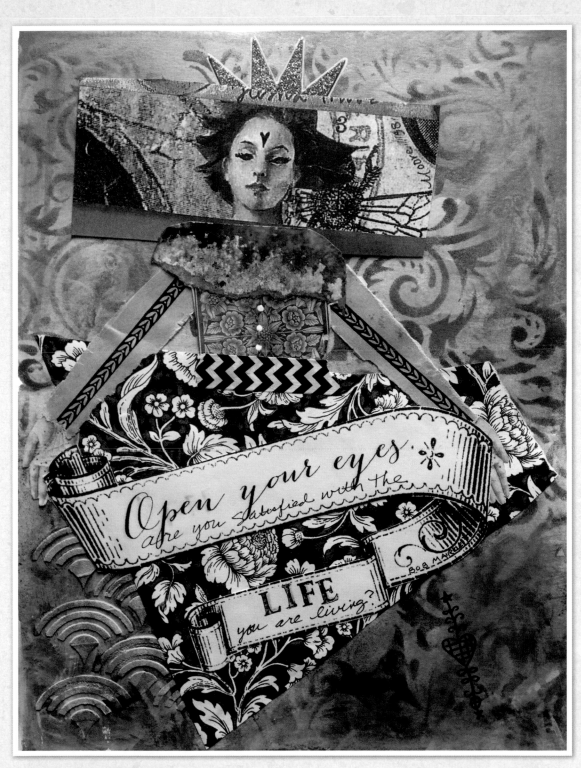

"Open your eyes. Are you satisfied with the life you are living?" —Bob Marley
Open Eyes
Lesley Riley
9" × 12" (23cm × 31cm)
Mixed media collage—digital, stamped and handwritten

CONTEXT OF THE ART'S STORY

Your quote can suggest an entirely different story, meaning or context depending on how you use and manipulate the composition ingredients. Aim for your illustrated quote to be as much an expression of yourself as the original meaning of the quote.

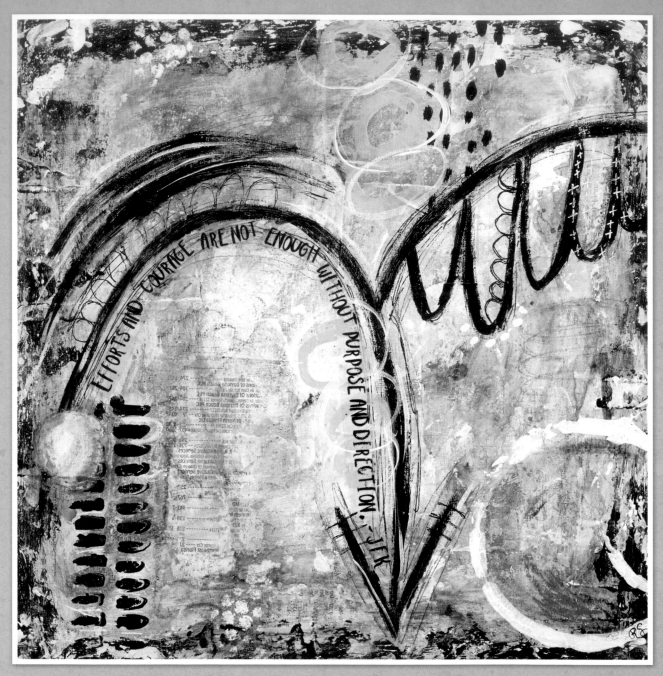

"Efforts and courage are not enough without purpose and direction." —John Fitzgerald Kennedy
Direction
Roben-Marie Smith
10" × 10" (25cm × 25cm)
Paper, acrylic paint, oil pastels, watercolor, gesso, pen and pencil on artist's board

ART, QUOTES AND COMPOSITION

As communicators, artists should not just portray a subject. Their work should be a window to the thoughts and inner workings of their artist lives and minds.

—Elizabeth Azzolina

A quote generates ideas and inspiration that get you to the table. Supplies and techniques move your vision from your head, through your hands and onto the paper. A knowledge of art principles and elements and the composition they create is what will help your finished art come close to looking like what you had in mind when you began.

Before we get to the nuts and bolts—the elements and the principles of art—and the subject of composition, I want to emphasize the most important and rarely mentioned ingredient in the study of art and composition: You.

You must always work from your heart. Art is your soul made visible. Creating art that looks like anyone else's lacks an important ingredient that enables and invites people to respond to your work. The tools of the elements and principles of design are also secondary to your vision. Think of them as concepts that assist you in conveying your thoughts and ideas in a visual way.

The value behind studying composition is to have an understanding of the rules and the tools—the whys and the reasoning behind how art is constructed. This includes knowing when to break them. Use them to help you express yourself and your vision and get your art out of your head and into the world in the best possible way.

THE ELEMENTS OF DESIGN

The elements and principles of design and composition are the *result* of creating art. You create composition (good or bad) every time you create art. Drawing, you create line. In collage, you use shape. By painting, stitching or gluing things on a canvas or quilt, you create space. When you add text in the form of a quote, you are working with the elements of line, shape, space, value and possibly color, as well as the principles of variety, balance, proportion and scale, repetition, harmony and unity. These are the ingredients you use when you create your art.

They are guides to creating a good composition because when you are trying to improve what you are creating or you are undecided about placement, color or direction, you consult what you know about these elements.

Line

Shape/Form

Value/Light

Texture

Space

Movement/Time

Color

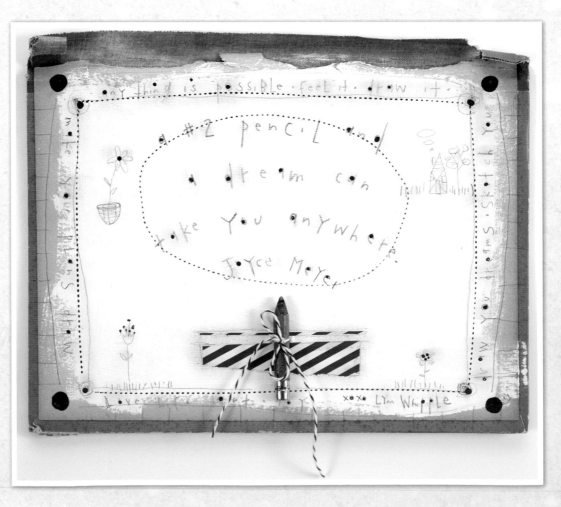

"A #2 pencil and a dream can take you anywhere." —Joyce Meyer
Number 2 Pencil
Lynn Whipple
10" × 8" (25cm × 20cm)
Mixed-media collage on old book cover

THE PRINCIPLES OF DESIGN

The principles are the rules or structure that you apply to the elements. These principles are the visual components that give structure to expression. The elements are what you use to create. The principles listed here are the results you get by using the elements.

Dominance/Focal Point

Contrast

Balance

Proportion/Scale

Repetition/Pattern

Rhythm/Movement

Variety

Harmony and Unity

Learn to recognize them in action by looking at artwork, both art that speaks to you and art that doesn't. Remember to really see that art! I do this all the time when looking at art or thumbing through a book or magazine. I pretend it's a Where's Waldo of composition principles and elements. It keeps my eye trained the same way shooting hoops does for a basketball player or the way playing scales on the piano keeps a pianist on top of his game.

It is hard to discuss the elements and principles of composition and design individually because they are so interrelated. They are always working together in a piece of art or craft. They borrow from each other as well—line can have shape; light can have pattern. Line creates shape and repetition creates harmony.

Your task is to
- become familiar with each element and principle.
- recognize them when they are used and/or applied.
- learn to apply them in ways to improve your art.

I could talk/write about this for days but it won't do you any good because in the end, you only learn by doing. Pay attention to the Why This Works section for each of the projects. Seeing composition elements and principles in action is the best way to learn.

KNOW YOUR INGREDIENTS
· · · · · · · · · · · · · · · · · · · ·

Illustrating a quote is not just about the lettering. It's also about where you place the letters, their size and style, and the materials you use. All of the elements and principles of design need to be taken into account in order to make your lettering efforts pay off.

I like to call design elements and principles "ingredients" because creating art is like cooking. There are recipes to follow, but you are free to improvise and encouraged to add the things you prefer and leave out those you don't. Just as I'm sure you do when you cook, you should not hesitate to put your own spin on things. Don't be so serious about doing it "right" or worried about being "wrong." It's art. There's room for error. In fact, you need to experiment in order to succeed.

WHAT IS GOOD COMPOSITION?

Good composition. You know it when you see it, but do you know how to create it? You create composition (good or bad) every time you create art. Everybody wants to create a good composition, but not everyone understands how. Composition is a result and a by-product. Composition happens whether you pay attention to it or not. Just as some people have a natural talent for drawing, others have a natural talent for composition. They do it intuitively. The opposite is also true. Some people are composition-blind (like tone-deaf), and they just don't see that it's off. Most of us fall somewhere in between.

First let's take a look at the simplest definitions and explanations of composition that I could find:

A putting together of parts or elements to form a whole; a combining.

—Tim McCreight

The arrangement of visual forces in space; synonymous with design.

—Steven Aimone

Designing, organizing or structuring a picture.

—Harry Sternberg

The act or process of composing; specifically: arrangement into specific proportion or relation and especially into artistic form.

—Merriam-Webster dictionary

My art idol, Robert Henri, author of *The Art Spirit*, says, "Composition is the freedom of a thing to be its greatest best by being in its right place in the organization. It is just a sense of the relation of things."

A sense. That's a good way to describe it, and I love his definition, but it is not very useful when you are trying to teach someone how to arrive at it.

Composition is a range, not a finite target. It goes from bad—glaring outpoints that everyone notices, to good—

subtle nuances that only the trained eye can detect, to great—work that sings!

You need to train your eye to detect areas and elements in your art that can be adjusted to create better composition and, as a result, better art. Most times you know something is off, but you just can't quite figure it out. Let me tell you why. (It's not your fault!)

We humans use our senses to survive. From the beginning we have relied on our eyes to quickly evaluate what we see and then categorize it as safe or not, friend or foe, good/bad, desirable/undesirable, etc. We are not conditioned to see details.

So how do you train your eye? First by learning to see, to really see, not just look. Sit down with an apple (any fruit, flower or plant will do) for fifteen minutes and, using all your senses, record everything you can about that apple. After the first minute or two you will learn you need to look harder and dig deeper for something to write. Persist and it will all open up for you. Make it a habit to really see, get to know and understand what is around you. The world is infinitely full of shapes, size relationships, color nuances, lines, rhythms, texture and more.

Artists notice. They dissect. They look to see the parts and look again to see how they combine to form the whole. They file it away for future reference. The more you learn to see what is presented to you moment by moment, the better will be the art you create. It's a lifelong lesson we can always improve on.

But know this: Composition skills do not ensure that the art will be a success. For every rule of composition there are wonderful examples of art that totally break the rules. Have you ever seen a painting or work of art that is technically perfect but leaves you cold? Or been drawn into a piece that has obvious flaws or is less than perfect? Art created by untrained outsider artists, naïve artists and children all have one thing in common: They completely put themselves into their art. There is no holding back.

Composition and technical skills should always be secondary to YOU. You are the most important element of your art. You must be willing to be less than perfect in order to create art that resonates with others. Perfection is the enemy. You, your feelings, your vision—you are the hero.

Sign up for our free newsletter at CreateMixedMedia.com.

3 STEPS TO SUCCESSFUL COMPOSITION

Creating the work comes first. Evaluating your use of the elements with your composition checklist is secondary. Once you know and understand the elements and principles, they will eventually become a part of your thinking and way of working. Over time it becomes intuitive and second nature.

Before we move on to the project section of the book, I'd like to briefly talk about the elements of design as well as the principles of design and composition. Here is what you will want to keep in mind:

The elements of design are your TOOLS.

The principles of design are the FRAMEWORK and GUIDELINES for using the TOOLS.

1. Create your art. As you create you automatically use art ELEMENTS. Learn to recognize them as you incorporate them.
2. When you get stuck or when you are finished, refer to the PRINCIPLES to evaluate your work.
3. Make adjustments, changes or corrections based on
 a. your personal preferences and choices
 b. the tried-and-true guidance of the art PRINCIPLES.

COMPOSITION CHECKLIST

PRINCIPLES

	Dominance	Balance	Proportion Scale	Repetition	Rhythm	Variety	Harmony Unity
Line							
Shape Form							
Value Light							
Texture							
Space							
Movement Time							
Color							

**ELEMENTS**

Composition Checklist

To help you evaluate your own work (and any other artwork you may look at to hone your eye) I have created a Composition Checklist. Print a few copies (go to CreateMixedMedia.com/creativeletteringworkshop to download a printable PDF), and use them to evaluate your work as you work through the three steps above or get stuck along the way. Place checks or notes in the boxes where an element and a principle intersect. Sometimes it's as simple as line + balance. Other times there are several things going on . . . or not going on.

Perhaps you find that you are lacking variety in shape or that there is not enough contrast or the wrong thing is dominating and creating an unintended focal point. Seeing the way they intersect and work together is helpful in learning how to create well-composed works of your own.

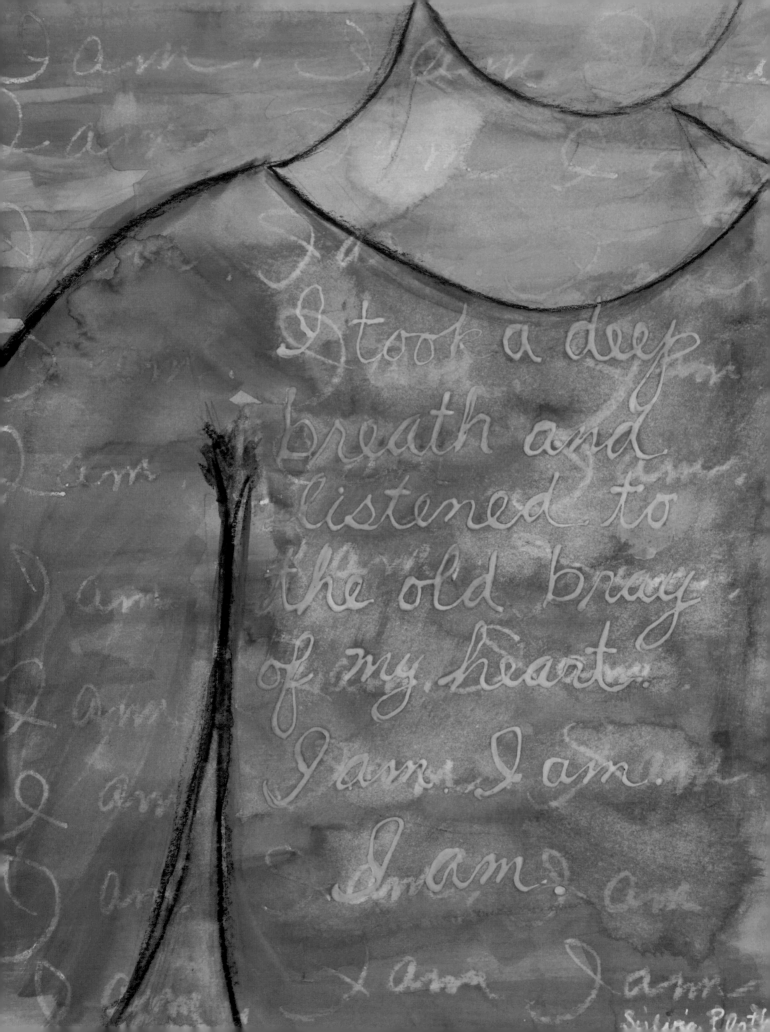

QUOTE + ART PROJECTS

I like thinking of possibilities. At any time, an entirely new possibility is liable to come along and spin you off in an entirely new direction. The trick, I've learned, is to be awake to the moment.

—Doug Hall

The hardest part of creating projects for this book was deciding which quotes, from my vast stash, to illustrate. Some ideas came to me immediately, like *An Old Coat* (Project 2) and *Magic Waiting* (Project 17). Other quotes were about feeling and emotion, which I felt could be best illustrated by the human face or figure. A few of my favorite quotes had to be set aside for later. Some ideas can take a very long time to percolate.

Overall, I want to provide you with a variety of styles, ideas and techniques to spark your own creations. Think of these projects—along with the work by all of the amazing and generous contributing artists—as a buffet of possibilities. Pick, choose and combine to your delight. Fill your plate and come back for seconds and thirds. Making art is a delicious calorie-free experience.

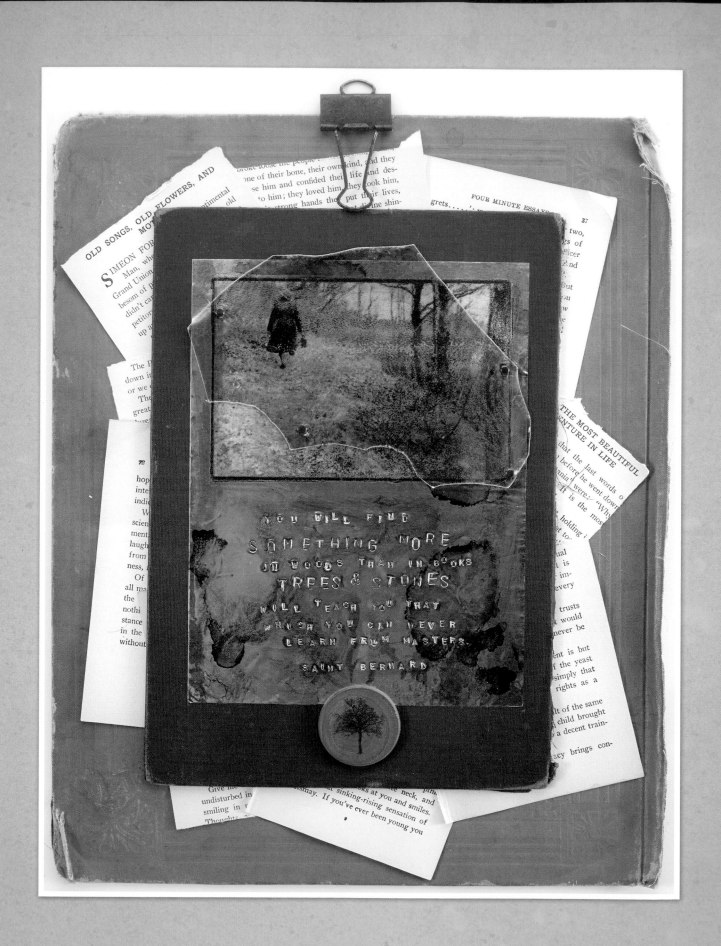

Sign up for our free newsletter at CreateMixedMedia.com.

WOODS VS. BOOKS

You will find something more in woods than in books. Trees and stones will teach you that which you can never learn from masters.

—Saint Bernard

This image of a woman walking in the woods is one I use frequently in my work and distribute to my students to use in my classes. It speaks volumes and works with so many different quotes. Her story can change with the turn of a phrase.

Why This Works

To enhance the story that this quote tells, I chose two vintage book covers (green for nature) and old book pages to add to the meaning and context. I brought in mica to add a natural element to connect the books to nature. The use of layering throughout also mimics the layers of pages in a book. The single tree transferred onto the red circle adds a punch of color, pulling the eye downward to ensure the text is seen. The circle is repeated in the brads attaching the mica. Brown ink helps to pull the eye downward as well as emphasize the stamped quote.

What You Need

- alcohol Ink (I used Ranger Adirondack in Ginger)
- all-purpose glue
- brads, small
- glue
- hole punch, small
- metal alphabet stamps & hammer
- metal foil sheet with TAP transferred image
- mica
- old book covers
- paper towels
- rubber stamp ink pad
- scrap paper
- torn book pages
- white paint

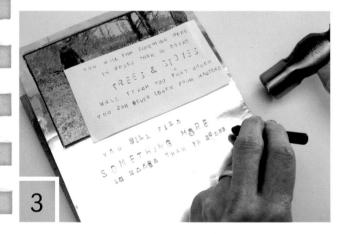

1

Choose an image that helps create the story of the quote and transfer it onto an adhesive-backed metal foil sheet using TAP Transfer Artist Paper.

2

To help you find the correct letters quickly, add a dab of white paint and write the corresponding letter on the top of each of the unmarked metal alphabet stamps.

3

Determine the spacing of your quote by stamping the quote onto scrap paper using a rubber stamp ink pad. Working on a firm but unyielding surface, so you do not hammer the letter through the thin foil, hammer the quote into the metal.

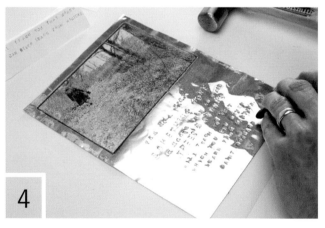

4

Continue stamping the entire quote into the metal, referring to your prestamped layout.

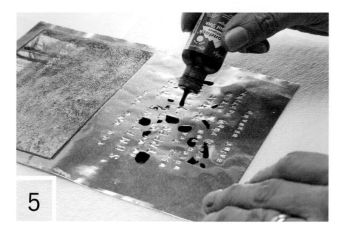

5

Drop alcohol ink over the stamped sections.

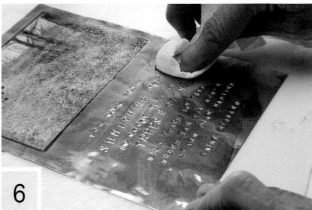

6

Allow it to settle into the grooves of the letters, then wipe away the excess ink to create your desired effect.

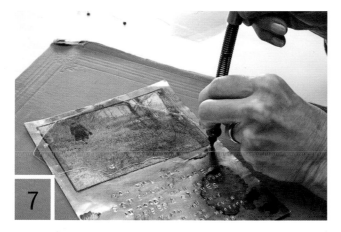

7

Punch small holes into the mica to create holes for brads that will attach the mica to the metal foil. (I used mini paper fasteners.)

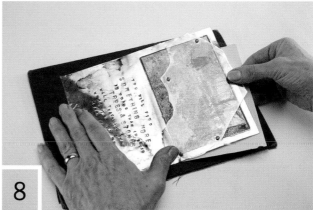

8

Attach the mica to the foil and remove the bottom half of the paper backing to expose the adhesive. Align it onto a small book cover. Remove the remaining paper backing and burnish the foil into place by hand. If your book cover has any embossing, additional burnishing of the foil in those areas will accent the texture.

Arrange the book pages onto the large book cover or your chosen background in a collage fashion. Lay the pages down to create a pleasing composition then carefully lift and glue each one into place. Glue the small book cover over the pages and continue to finish the artwork with any additional embellishments that reinforce the quote's message.

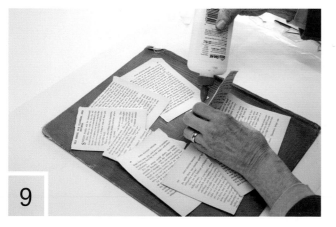

9

I'd gone through life believing in the strength and competence of others, never in my own. Now dazzled, I discovered that my capacities were real. It was like finding a fortune in the lining of an OLD COAT

JOAN MILLS

AN OLD COAT

I'd gone through life believing in the strength and competence of others; never in my own. Now dazzled, I discovered that my capacities were real.
It was like finding a fortune in the lining of an old coat.

—Joan Mills

While I know money doesn't buy happiness, it's always a great feeling and fun surprise to find some in your pocket. A student of mine shared this quote with me in 2004, and it has been one of my favorites ever since. It describes so well how I feel about my journey as an artist. I never thought I could do it justice with my art, but I am willing to try.

Why This Works

Handwriting the quote seemed to be the best way to have it flow within the overall composition. It is a softer approach to adding text that fits well with the lining of the coat. The block of text and the right side of the coat are well balanced. To keep it from being too static overall, I added a pop of color, texture and contrast with the die-cut letters.

What You Need

cartridge ink pen (Pilot Parallel Pen, 2.4 mm)

die-cut letters

glue

mixed-media paper (Strathmore)

prepared watercolor painting

scrapbook paper

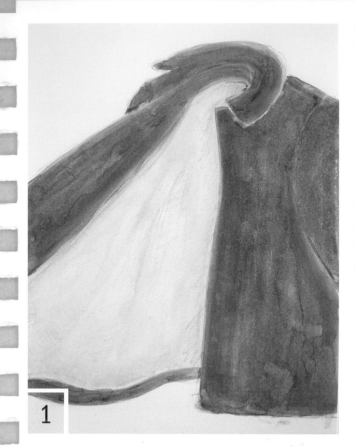

Work on the smooth, dry surface and write the quote with a cartridge ink pen.

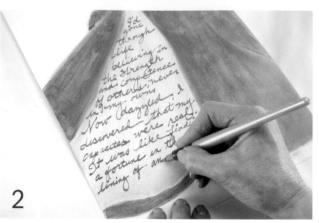

Create a background that sets the stage for your quote. Keep in mind which writing and painting materials work well together. Here, watercolor was used to paint the coat on mixed-media paper.

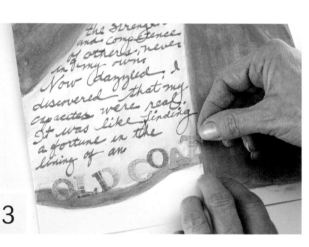

Cut the final words out of scrapbook paper using die-cut letters. Glue them into place to create an interesting finish and bring attention to the lining of the coat.

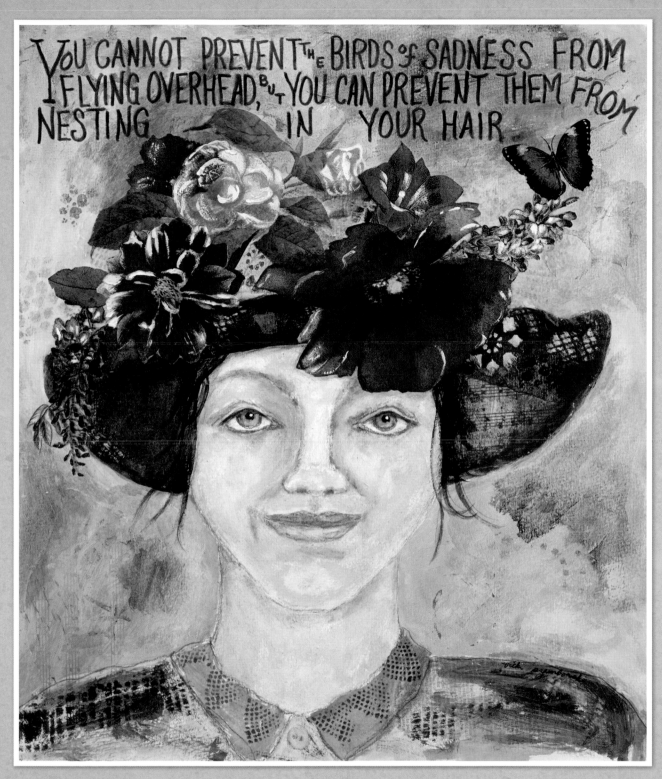

"You cannot prevent the birds of sadness from flying overhead, but you can prevent them from nesting in your hair." —Chinese Proverb
Nesting
Vicki Szamborski
12" × 14" (30cm× 36cm)
Acrylic paint and collage on watercolor paper

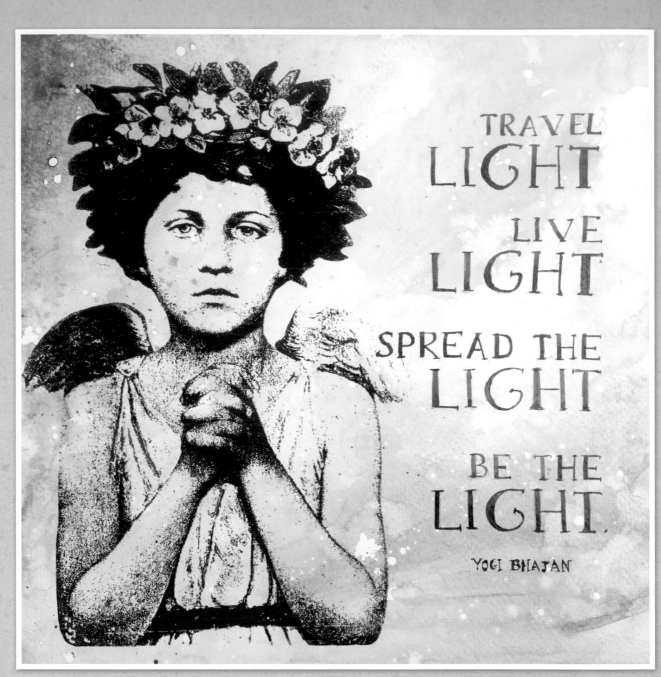

TRAVEL
LIGHT
LIVE
LIGHT
SPREAD THE
LIGHT
BE THE
LIGHT.

YOGI BHAJAN

BE THE LIGHT

Travel light. Live light. Spread the light. Be the light.

—Yogi Bhajan

We all have problems but I never want to dwell on them or let them affect my time with others. This quote speaks to me on so many levels. I truly want to spread and be the light, or as Maya Angelou says in the quote Jenni Adkinks Horne illustrated (following Project 19), "a rainbow in someone's cloud." I created the bright background with spray inks and frisket to mask some white areas. A TAP transfer of an angel image I have used in my work for years gives this piece added meaning for me.

Why This Works

Proportion and color were used to balance the two sides of this piece so neither the image nor the quote overpowers the other. Simplicity at its best!

What You Need

dip pen/nib

graphite transfer paper, erasable

ink (I used Dr. Ph. Martin's Bombay India Ink in Turquoise)

prepared artwork using spray inks, masking fluid and TAP transfer

watercolor paper, hot-pressed (Strathmore)

white eraser

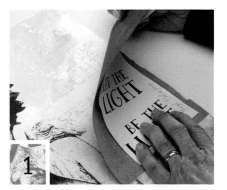

1 Preprint your quote in a decorative font, sized and spaced to fit on your artwork. Lay the printed quote over erasable transfer paper and trace the quote onto the artwork.

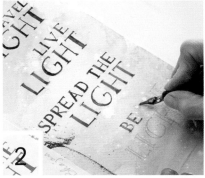

2 Use a dip pen and acrylic ink to letter over the traced quote. Let the ink run low on the nib before dipping for more ink to create variety in the color of your strokes.

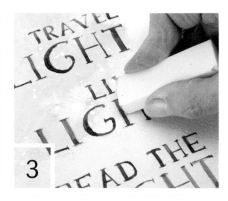

3 Allow the ink to dry thoroughly. Gently erase the traced lettering with a clean white eraser.

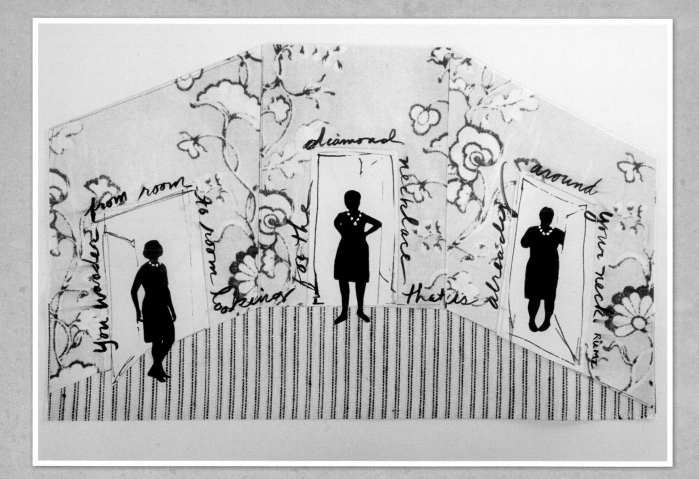

DIAMOND GIRL

*You wander from room to room
hunting for the diamond necklace
that is already around your neck!*

—*Rumi*

Just reading this quote conjures up such a clear visual image for me. We've all done the room-to-room thing looking for something. In life, as in looking, I have come to realize that most of the time what we are searching for is right under our nose. We have just been too close to see it, or not been expecting to already hold within ourselves the very thing we seek.

Why This Works

I kept pretty close to my original sketch to keep it loose and used subtle background colors of scanned fabric and lots of open space to give the wandering figures more impact. I wanted the text to wander as well but not detract, so I kept it close to the shapes and lines created by the composition. Keeping the figures simple ensures that the diamonds stand out. Repetition emphasizes the room-to-room wandering.

What You Need

Japanese brush pen, soft nib

pencil

photocopy or tracing of finished art

prepared background (I used collaged papers)

1

Prepare artwork that helps tell the story of the quote and allows space to add the quote in such a way that its spacing reinforces the message. Use tracing paper to determine quote spacing.

2

Use your own handwriting to write the quote in a color and size that almost fades into the background.

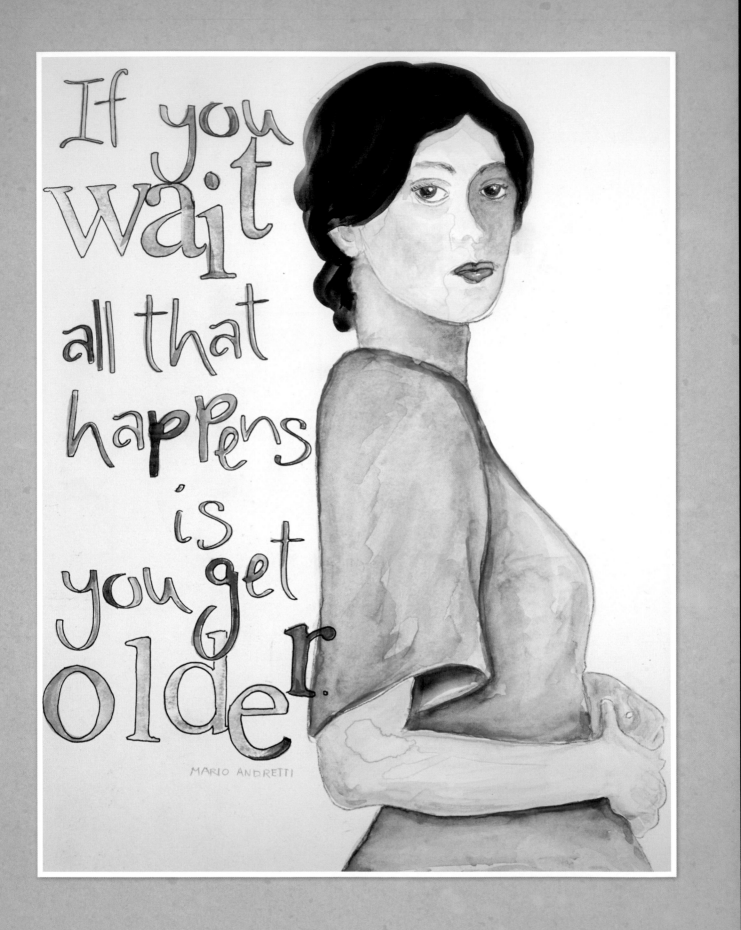

If you wait all that happens is you get older.

MARIO ANDRETTI

IF YOU WAIT

If you wait, all that happens is you get older.

—Mario Andretti

Waiting for certainty, waiting for available time, waiting until you have the right space, plan, tool or idea—we waste so much time waiting. As a late bloomer I can't afford to wait and therefore take advantage of every five, ten or fifteen minutes I have and work in the space I have with the materials at hand. I know that the ideas and inspiration will start to flow as soon as I begin.

Why This Works

The prominent use of blue letters and the large lettering of the quote, along with the addition of the oversized stamped words, especially at the bottom, balance the composition overall and especially work to draw our attention away from her stare. Additional colors in the lettering add variety. The lips are just red enough and add a nice pop of color without overpowering the entire piece.

What You Need

- alphabet stamps, large
- alphabet stencil (I used a Crafter's Workshop Alphabet)
- brush markers or pens (I used Akashiya Sai Watercolor Brush Pens)
- Faber-Castell Pitt Artist Pen
- prepared artwork on mixed-media paper (sketched and watercolor-painted figure)

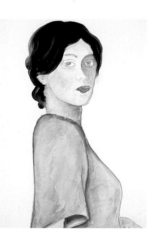

1

Draw or paint a figure that appears as if she is actually saying the quote.

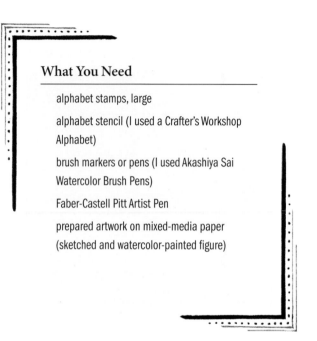

2

Use a lettering stencil and a thin small-nib pen or permanent ink pen or marker to trace the quote onto your artwork. To determine spacing and allow room for some larger contrasting words, it is helpful to do a practice run on a copy of the art or on tracing paper.

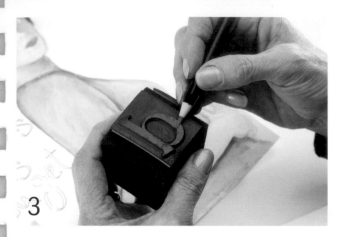

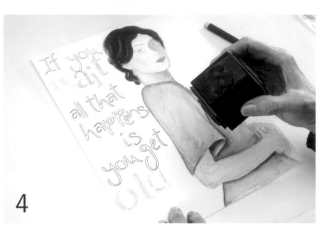

3

Use a large alphabet stamp set and color the letters with water-color brush markers or use a stamp pad.

4

Stamp the large words onto the art.

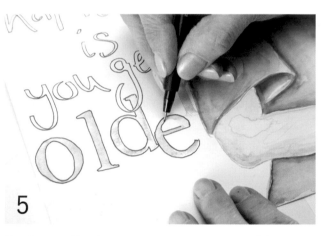

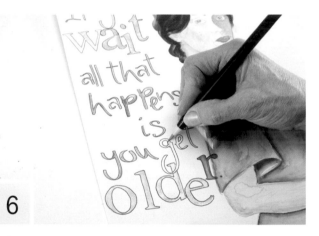

5

Use the same fine-tip permanent pen to trace around the stamped letters to add definition.

6

Color in the stencilled letters with the watercolor brush markers, using two or three colors for variety.

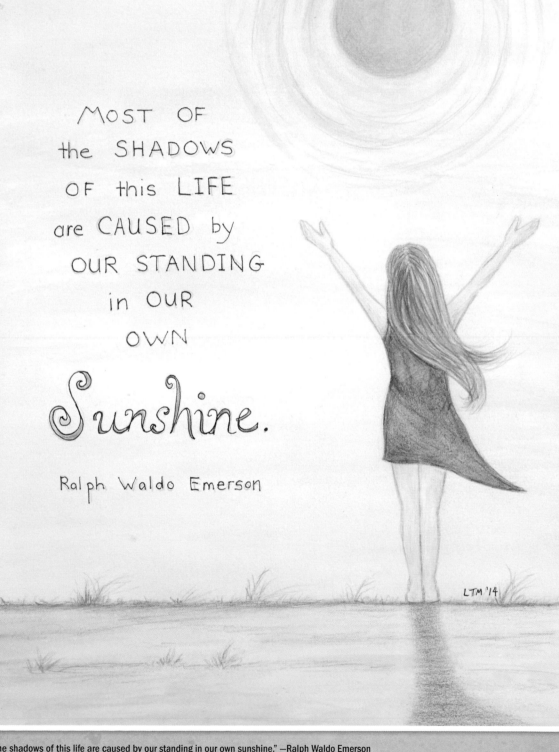

"Most of the shadows of this life are caused by our standing in our own sunshine." —Ralph Waldo Emerson
Sunshine and Shadows
Laura Taylor Mark
9" × 12" (23cm × 30cm)
Watercolor, colored pencils and pen on mixed-media paper

I love writing. I love the swirl and swing of words as they tangle with human emotion.

JAMES MICHENER

Sign up for our free newsletter at CreateMixedMedia.com.

I LOVE WRITING

*I love writing. I love the swirl and swing of words
as they tangle with human emotions.*

—James Michener

James Michener and I have something in common! This piece was inspired by my love of writing and of letters as art elements. Using one of my oil-board alphabet stencils reinforced my theme. I wanted to pair a letter with a quote on letters or writing and went in search of one. The swirl and swing that Michener wrote led me to the letter S. Don't you love how the words swing and swirl around the S shape?

Why This Works
Repetition—of shape, sound, the letter S, the swirl and swing of the written word, and the writing on the background.

What You Need

acrylic round brush (or Incredible Nib)

all-purpose glue

art surface (I used oil-board stencil and a canvas board covered with my own custom printed and painted paper)

large letter stencil

masking fluid (I used liquid frisket)

rag or paper towels (if using nib)

rubber eraser

water

watercolor or fluid acrylic paint

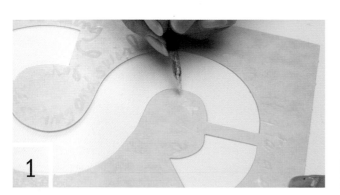

1

After determining your spacing on a practice copy, wet the tip of the nib or brush with water and blot any excess. Write the quote onto the stencil using liquid frisket and an Incredible Nib or a round brush. Allow the frisket to dry.

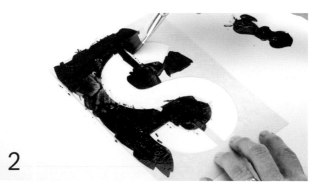

2

Paint over the entire stencil or artwork with acrylic paint. (Watercolor paint will also work, depending on your surface, but I couldn't use it on this waxed stencil.)

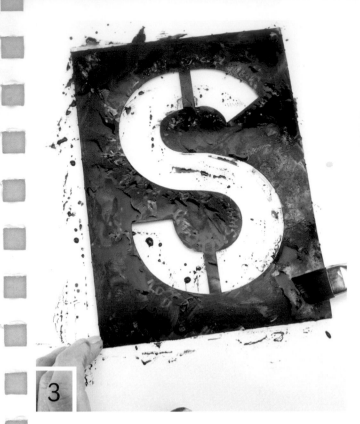

4

Using a rubber eraser (mine came with the frisket), remove all of the frisket, revealing the written quote.

3

Let the paint dry.

5

Adhere the stencil to a prepared background of your choice.

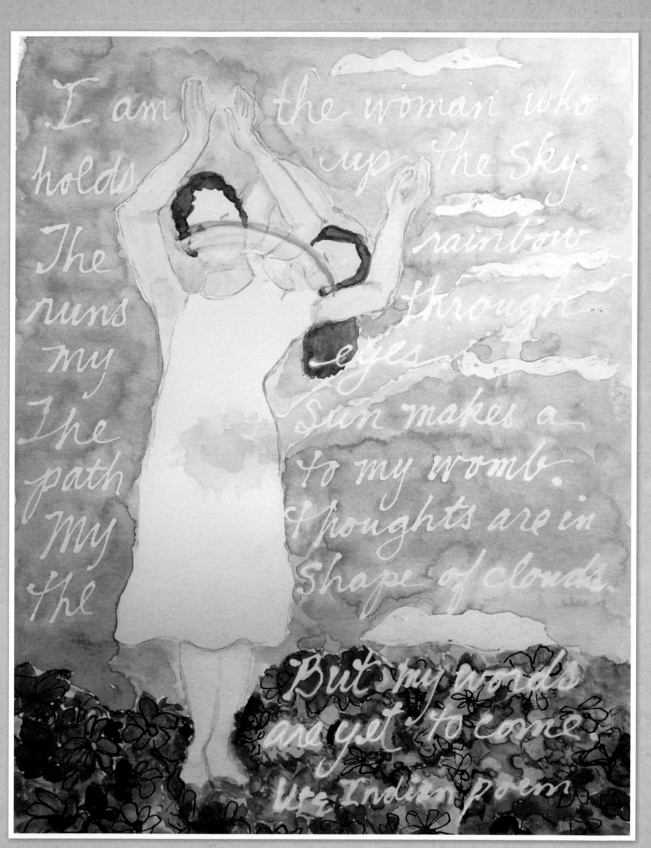

"I am the woman who holds up the sky. The rainbow runs through my eyes. The sun makes a path to my womb. My thoughts are in the shape of clouds. But my words are yet to come." —Ute Indian poem

I Am the Woman

Lesley Riley

9" × 12" (23cm × 31cm)

Watercolor and liquid frisket mask written with Fineline applicator on mixed-media paper

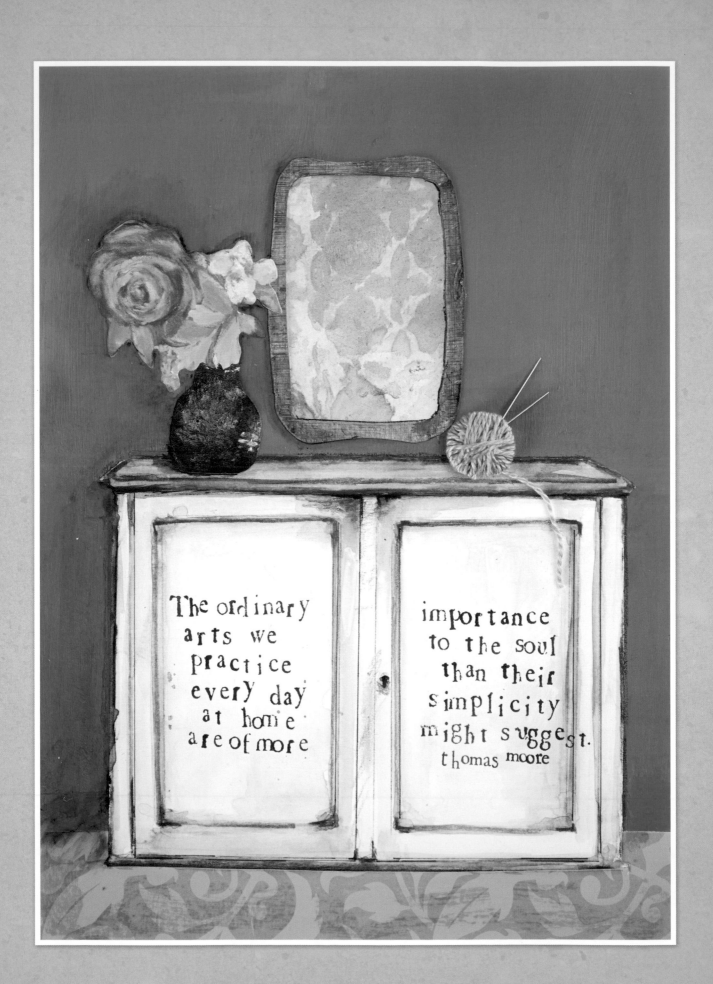

The ordinary arts we practice every day at home are of more importance to the soul than their simplicity might suggest. thomas moore

PROJECT 7

ORDINARY ARTS

The ordinary arts we practice every day at home are of more importance to the soul than their simplicity might suggest.

—Thomas Moore

"There's no place like home," says Dorothy in Oz. Creating a home of comfort, love and beauty is an art in itself, one that is often overlooked or undervalued. Just as we tend a garden, our home tends to our soul. As a bonus, illustrating this quote enabled me to do a little imaginary redecorating on the cheap!

Why This Works

Adding the quote in a layout that repeats the shape of the cabinet doors and the artwork above helps to seamlessly integrate it into the composition. The elements atop the cabinet draw the eye away from the high contrast of the dark lettering on white, while the "rug" repeats the patterning in the framed art and provides grounding for the piece.

What You Need

alphabet stamps, 2 sizes

prepared artwork (painted chest and background with mixed-media collage)

rubber stamp ink

1 Create artwork that illustrates the quote and allows room for stamping the quote.

2 Stamp the quote using a small alphabet stamp set and rubber stamp ink in a coordinating color. As an option, use an even smaller stamp set to add the attribution.

3 Complete the artwork by adding any additional embellishments that add to the story of the quote.

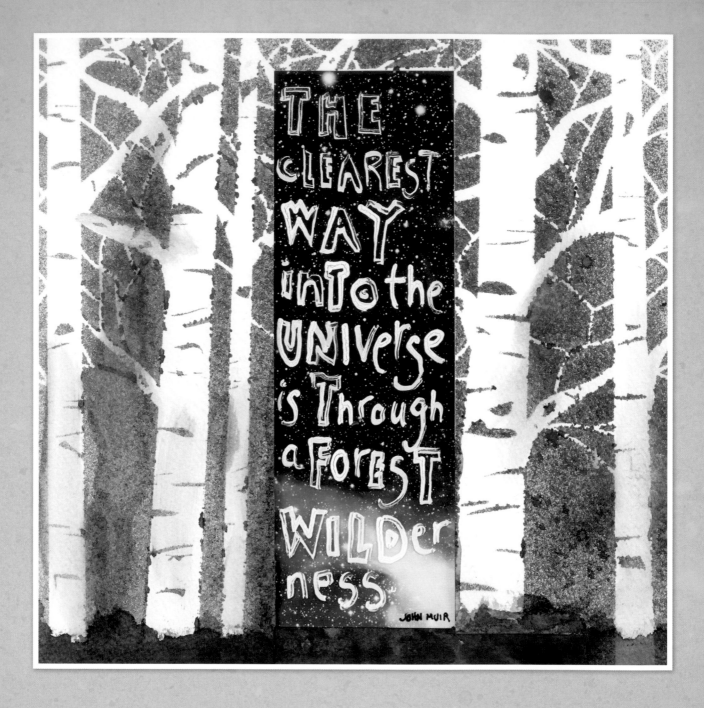

THE CLEAREST WAY INTO THE UNIVERSE IS THROUGH A FOREST WILDERNESS

JOHN MUIR

FINDING YOUR WAY

*The clearest way into the Universe is
through a forest wilderness.*

—John Muir

It was entirely unintentional, but I see that I have developed a theme with many of the quotes I chose for this book. I think that's exactly what this quote is telling us. The tens of thousands of quotes available to us are our forest wilderness. Finding your way by choosing the ones that resonate the most with you leads you to the insight you seek. In this case, the birch tree stencil that I fell in love with was my inspiration. I used it as my starting point. Finding just the right quote came last.

Why This Works

The use of the transparency behind the cutout area of the stencilled artwork enables me to create the illusion of depth that is implied in the quote. Adding bold white-stacked lettering ties it in with the vertical strength of the bold white trees.

What You Need

craft knife to cut opening (optional)

glue

ink-jet transparency

low-tack tape

paint marker (Liquitex)

photo of Carina Nebula (photo credit: ESO/T. Preibisch)

prepared artwork (embellished stencilled image)

ruler

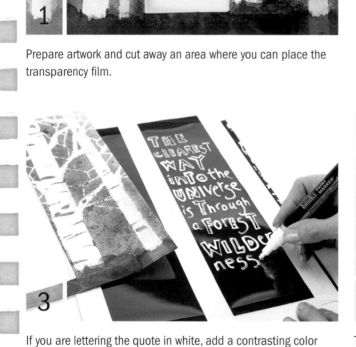

1

Prepare artwork and cut away an area where you can place the transparency film.

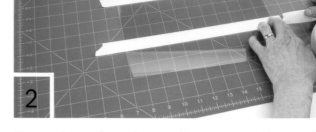

2

Measure the opening and use masking tape to provide a spacing guide for your lettering.

3

THE CLEAREST WAY inTo the UNIVERSE is Through a FOREST WILDerness

If you are lettering the quote in white, add a contrasting color behind the transparency to help you see what you're doing.

4

Trim the lettered transparency a bit larger than the size of the opening. Place the lettered transparency on the back of the artwork and tape it in place. Position the preprinted galaxy photo behind the transparency. Add glue to the outer margin on the printed side of the image, away from the transparency. Glue in place.

"Live your questions now. Perhaps you will then gradually, without noticing it, live along some distant day into the answer." —Rilke

Live Your Questions
Jennifer Joanou
9" × 12" (23cm × 30cm)
Ink, paper and acrylic paint on watercolor paper

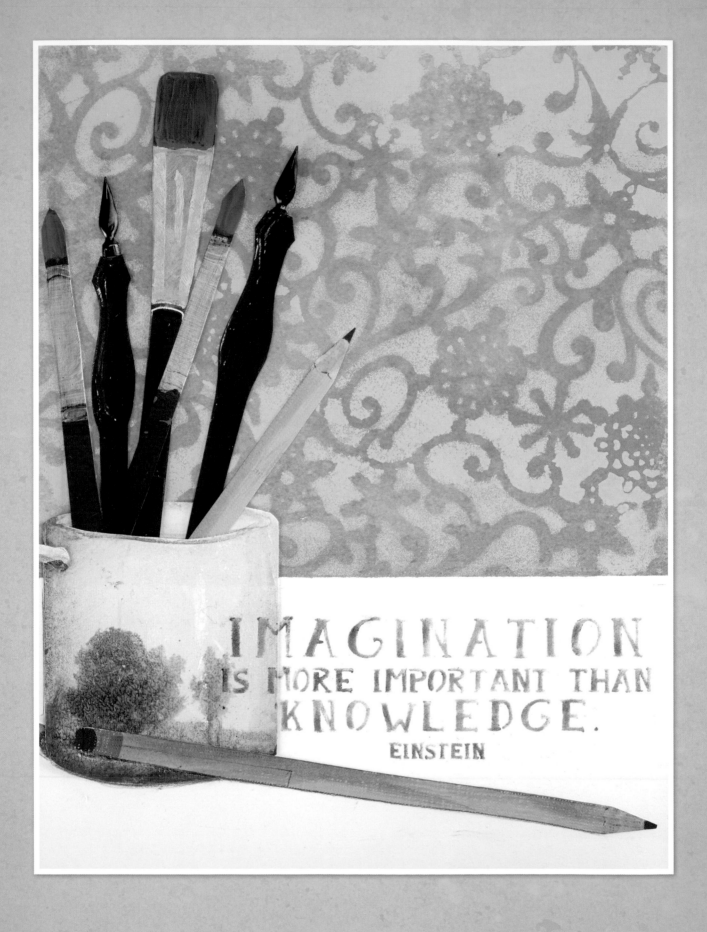

IMAGINATION

Imagination is more important than knowledge.

—Albert Einstein

I grew up in a time when the belief was knowledge equaled success. Many of my childhood memories are of the attempts my teachers made to tame my imagination in order to get my attention so they could do their job—impart knowledge. They were quite successful and instilled in me a love of and lifelong quest for knowledge. All of this knowledge is finally paying off, not just for me, but also for society, as we now recognize what Einstein tried to tell us—that imagination truly is more important than knowledge. They really do make a great team, but we know the scales are tipped. I used my Pen & Ink stencil to create the collaged art tools. The cup was painted before adding the TAP transfer.

Why This Works

The strong background pattern and the upward pointing of the art tools in the upper two-thirds of the background are balanced by the stark and open contrast of the white lower third and the large stencilled quote, which draws the eye. The stray pencil creates interest and further acts to draw the eye downward and provide an anchor for the quote.

What You Need

collage elements from stencils

fixative

glue

painted and stencilled background

PanPastels

quote stencil

sequin, pen-tip

Soffit tool for pastels

stencil, Pen & Ink (StencilGirl)

1

Prepare a background with acrylic paint and a stencilled design.

2

Collage the mug and drawing tools onto the prepared stencilled background.

3

Use the designed stencil and PanPastels with a Soffit tool to add the quote. Finish adding color for each word.

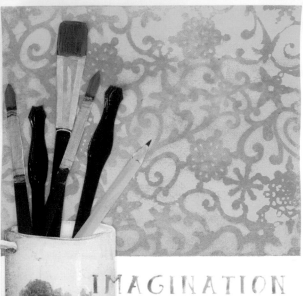

4

In a well-ventilated area, spray the pastel with fixative so it doesn't smear. Let dry.

5

Add more three-dimensional elements to the image. I used sequins to create the tips for the pens.

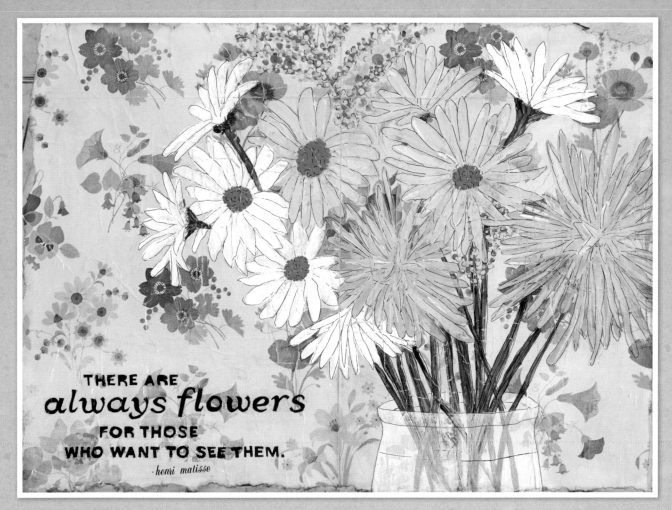

"There are always flowers for those who want to see them." —Henri Matisse
There Are Always Flowers
Tiffin Mills
16" × 12" (40cm × 30cm)
Vintage wrapping paper, acrylic paint and PanPastels on wood panel board

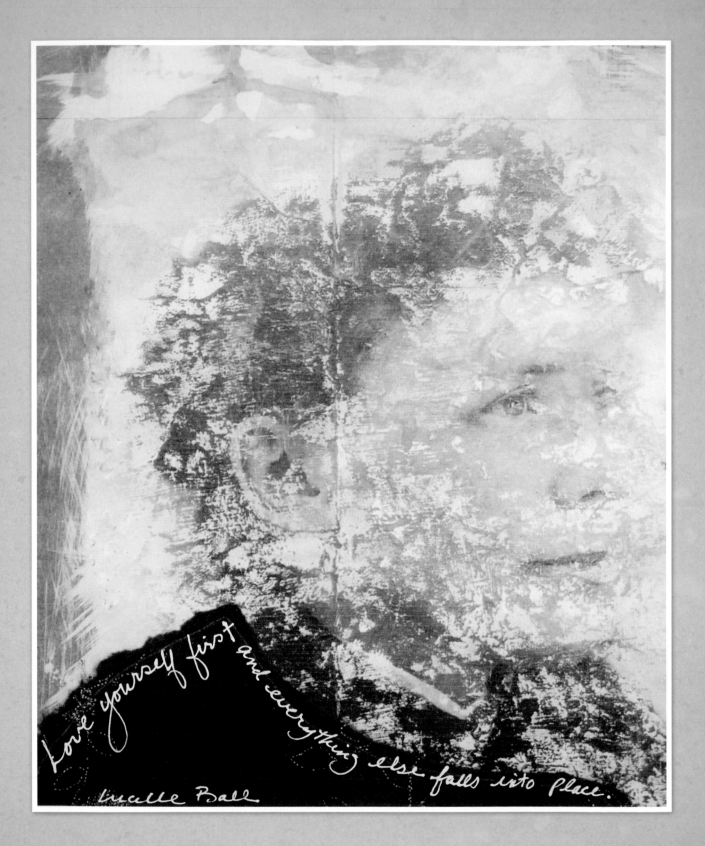

Love yourself first and everything else falls into place.

Lucille Ball

LOVE YOURSELF

Love yourself first and everything else falls into place.

—Lucille Ball

I agree with Lucille Ball. I also feel that it is important to learn to love your art. This image was created with recycled art—a cropped and enlarged detail of a transferred image on the page I created in my friend Lynne Perrella's round-robin *Alphabetica* journal. Being my first round-robin and the first one to work in Lynne's journal was extremely nerve-wracking, to say the least. I believe that was the day I learned to love my art. And looking at it now, ten years later, I think I did the right thing. This particular quote adds special meaning to the expression on the woman's face, but another story can easily be told by choosing a different quote.

Why This Works

Sometimes illustrating a quote is as simple as finding the perfect placement for your own handwriting. I did not want the quote to detract from the image or get lost on the page. By using a white pen along the lines of her clothing, the quote at first glance appears to be dress trim.

What You Need

gel pen, white (Signo Uni-Ball)

image printed on mixed-media paper

1 Find a piece of your old artwork. Crop and enlarge it to fill a page. Print it on mixed-media paper cut to fit your printer.

2 With a white pen or marker, add the quote to the artwork.

For additional downloads from the book, go to: CreateMixedMedia.com/creativeletteringworkshop.

75

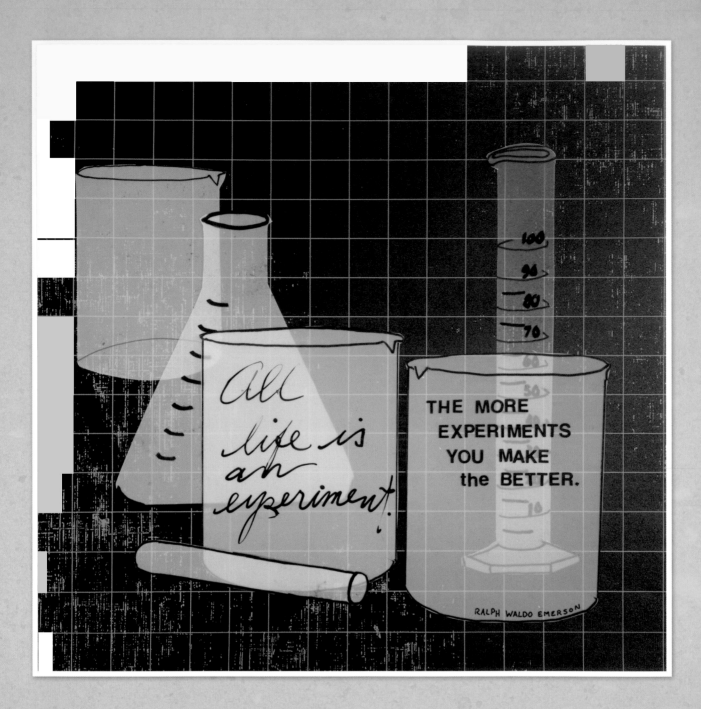

CHEMISTRY

All life is an experiment. The more experiments you make the better.

—Ralph Waldo Emerson

I have fond memories of chemistry class even though most of my experiments failed in spite of having a lab partner who went on to become a doctor. Art is a lot like chemistry. You mix ingredients, hope for a certain outcome, but really never know how it will turn out. Plus, both involve a lot of cool potions, fun tools and surprise.

Why This Works

In order for my idea for this quote to work, I had to find a transparent or translucent surface to write on, as other options like stickers, rub-ons or stamping seemed too overpowering. I considered several options but a bit of India ink on Dura-Lar solved the problem. As it turns out, using sticker letters for part of the quote was just the right contrast to keep the composition from being too static. The graph paper background reminds me of my chem lab notebook. If you start in the upper left corner, you can see how the eye flows down and across the shapes, the text and back up to the tip of the tall cylinder on the right. Composition is all about directing the eye.

What You Need

- decorative paper
- fine-line applicator
- India ink
- permanent maker (Pigma Micron Graphic #1)
- scissors
- spray adhesive
- stick-on letters
- translucent paper (Dura-Lar)
- tweezers (optional)

1

Trace or draw shapes onto translucent paper that will accept India ink. Cut out shapes.

2

Fill the fine-line applicator with India ink. Hold it at a 90-degree angle to control the flow and write a portion of the quote on one of the shapes. Let dry.

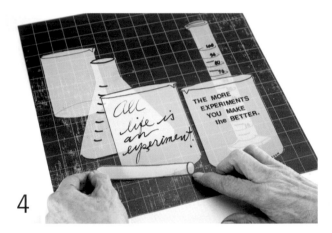

3

To add variety, use stick-on letters to complete the quote. Use tweezers to make placement of the letters easier.

4

Add any additional marking with a permanent marker. Use spray adhesive on the backs of the shapes. When dry, overlap the shapes into an interesting composition.

"You can never get a cup of tea large enough or a book long enough to suit me." —C. S. Lewis

Early Morning Tea
Lois Parks DeCastro
9" × 11" (23cm× 28cm)
Digital art: scanned Gelli print and painted collage, digital enhancement and text

For additional downloads from the book, go to: CreateMixedMedia.com/creativeletteringworkshop.

79

My thoughts
are stars
cannot fathom
into
constellations
John Green

FATHOM

My thoughts are stars I cannot fathom into constellations.

—John Green

When I saw this quote I was immediately struck with an idea for illustrating it. That initial vision also gave me the push I needed to create the stencils I needed to complete the art I envisioned. What you see isn't exactly what I envisioned. It's better! I love when that happens. I used the same recycled image from a previous project, *Love Yourself*, this time as a TAP transfer over a vintage nautical map that was scanned and printed on mixed-media paper.

Why This Works

The use of a limited color palette prevents the image and quote from overpowering the subtle stars that were the intended focus of this piece. The white lettering of the quote is balanced by the white cluster of stars. The figure and her thoughts become a part of the universe. A strong white line of the galaxy down the center of the composition could become an unintended focal point, but it is offset by the scale and contrast of the woman's face, drawing us deep in the picture and message. I didn't even notice it when I was composing the piece!

What You Need

glue

prepared background

stamp pad, white (StazOn)

star embellishments

stencil, Starry Night (StencilGirl)

stencil dauber

TAP transfer

white paint pen, fine-tip (Sharpie)

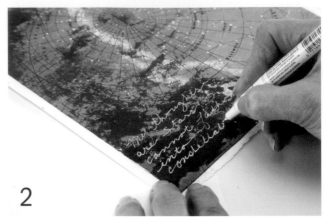

2

Use a fine-tip white paint pen to write the quote over the TAP transfer.

1

Print a map onto watercolor paper, then apply a TAP transfer over the printed image.

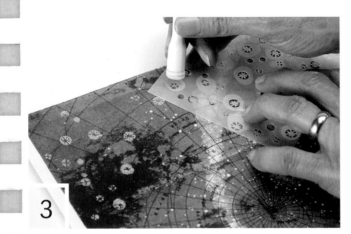

3

Stencil stars onto the artwork using a white stamp pad and dauber to add contrast and dimension.

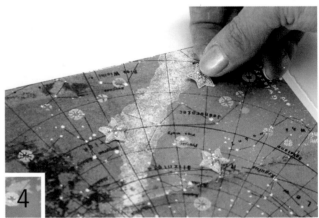

4

Add additional star embellishments for variety and texture.

Sign up for our free newsletter at CreateMixedMedia.com.

"Imagine inventing yellow or moving for the first time in a cherry curve." —M.C. Richards
Cherry Curve
Loretta Benedetto Marvel
9" × 12" (23cm × 30cm)
Watercolor, gouache and Pitt Artist Pen on 140-lb (300gsm) hot-pressed paper

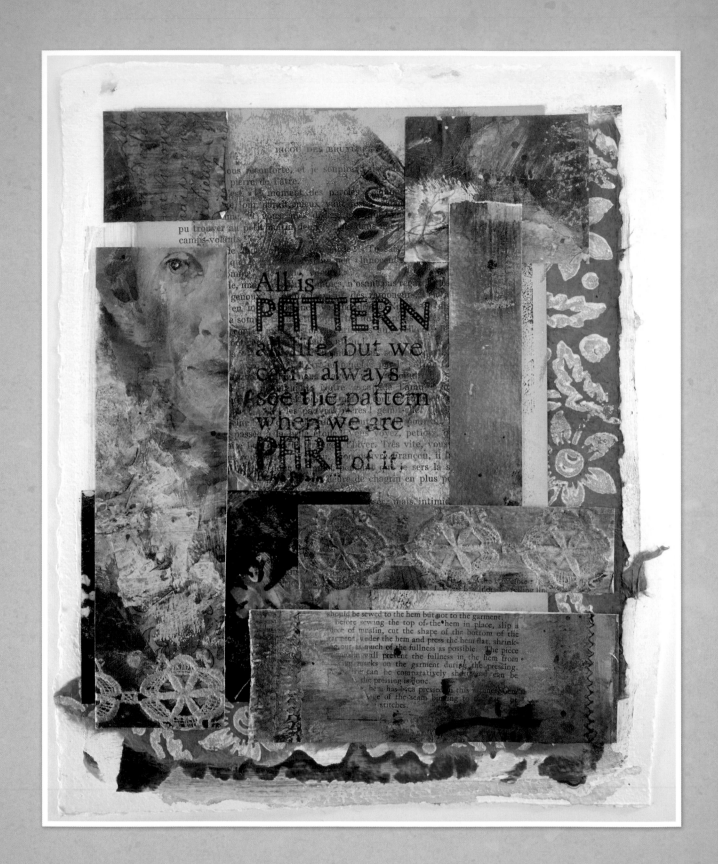

Sign up for our free newsletter at CreateMixedMedia.com.

FIND THE PATTERN

*All is pattern, all life, but we can't always
see the pattern when we are part of it.*

—Belva Plain

Pattern is such an important art ingredient. It is created through the repetition of an art element in a piece. You create it whether you try or not and sometimes can only see it when the piece is done. It's not so easy to see the pattern of our life. Yet our routine is pattern. We don't always like disruption in our daily pattern, but that's what makes life interesting. Don't be afraid to change your pattern. Variety is good for you and your art.

Why This Works

There's a lot of pattern and texture going on in this piece. Transferring the quote onto pattern integrates it so the quote and its variety in font and letter size become part of the overall pattern. The use of these patterns, complementary colors and texture throughout the composition creates a well-integrated piece and keeps the large quote from stealing the show.

What You Need

- fine-tip waterproof pen (optional)
- foam brush
- ink-jet transparency, preprinted with quote in reverse
- prepared collaged artwork
- soft gel medium
- spoon

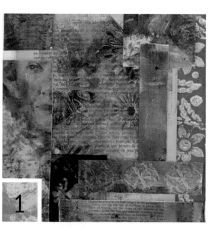

1. Create a mixed-media collage, leaving a flat smooth area to transfer your quote.

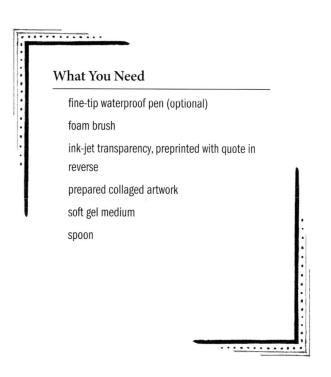

2. Apply soft gel medium to the smooth area with a foam brush. Apply enough medium so your finger easily glides across the medium but the surface is not wet enough to cover your finger with medium.

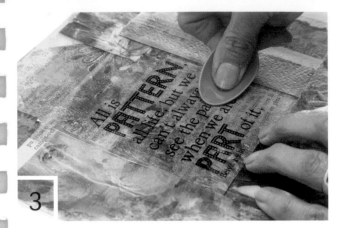

3

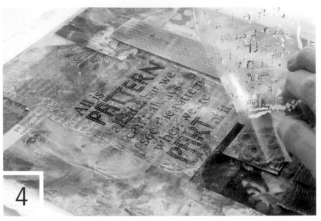

4

Lay the transparency, printed-side down, onto the soft gel medium surface and quickly burnish with a spoon. Do not let the medium dry as the transparency will stick and pull up the transfer and possibly the paper underneath.

Check to see if most of the text has transferred, and peel away the transparency while still wet.

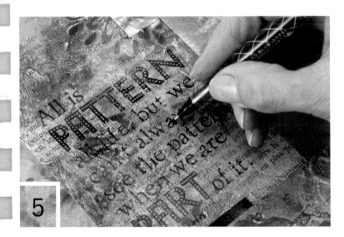

5

Touch up any incomplete letters with a fine-tip waterproof and permanent pen if desired. Alternatively, grunge and illegibility might just be what you are looking for.

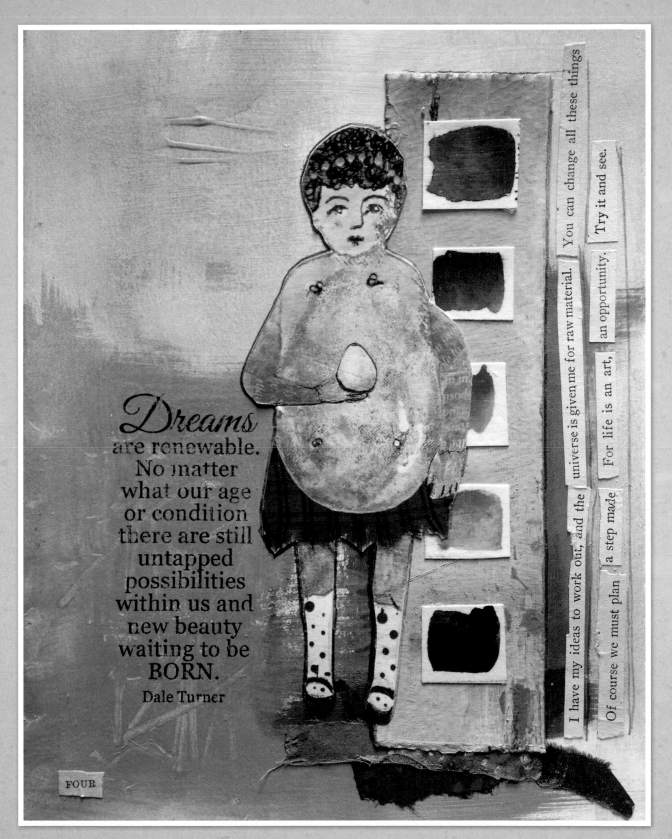

"Dreams are renewable. No matter what our age or condition there are still untapped possibilities within us and new beauty waiting to be born." —Dale Turner

Renewable

Lesley Riley

7" × 9" (18cm × 23cm)

Mixed-media collage and transparency transferred quote on watercolor paper

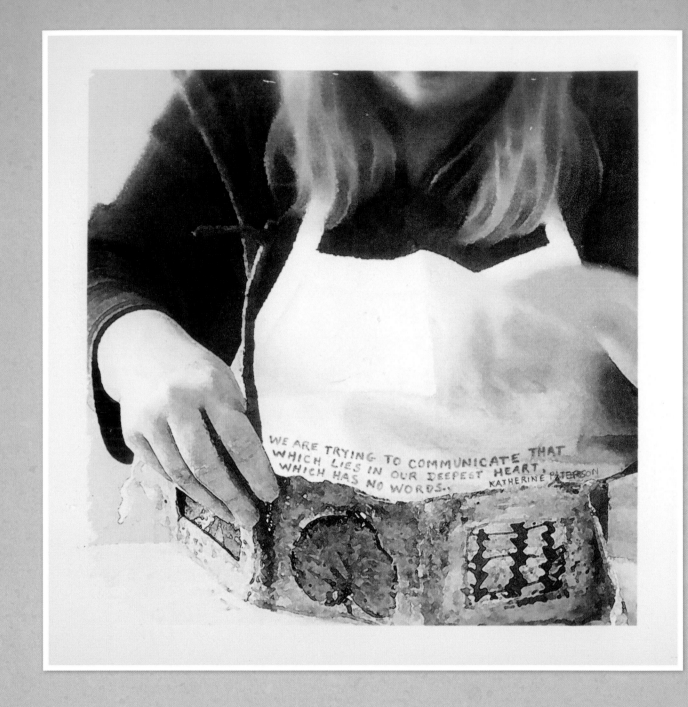

WE ARE TRYING TO COMMUNICATE THAT WHICH LIES IN OUR DEEPEST HEART, WHICH HAS NO WORDS. KATHERINE PATERSON

NO WORDS

*We are trying to communicate that which lies in
our deepest heart, which has no words . . .*

—Katherine Paterson

Art is a form of communication. When we create art, we are communicating with ourselves first and foremost. Whether anyone else sees it or not, we make a valuable connection with ourselves. We make meaning. It is our job to create the art, not to care what others think of it. When you create from that place, people take notice. Message received. 10-4, copy that. The image is a TAP transfer of an original photo onto watercolor paper.

Why This Works

I instantly knew that I wanted to write the quote on the artist's apron and work it into the art in such a way that it would appear to be a part of the image. By matching one of the colors in the photo and delicately printing the quote alongside similar colors, I was able to integrate it so it did not detract from the delicate coloring in the photo.

What You Need

pen, pencil or marker

prepared artwork

1

Transfer a photo to watercolor paper using TAP Transfer Artist Paper.

2

Choose a pen, pencil or marker in a color to match one of the colors in the the photo. Letter the quote in a spot that blends into and integrates well with the photograph.

There is no
greater agony
than bearing
an untold
story
inside.

Maya Angelou

PROJECT 15

UNTOLD STORY

There is no greater agony than bearing an untold story inside.

—Maya Angelou

Some of my first forays into art were created to honor the women who were silenced for so many centuries and, in many places, still are. Throughout history women did not have the time, materials or *permission* to create anything, so few found ways to express themselves creatively, usually through healing and home arts. Considering the unlimited opportunities and abilities we have to tell our stories, why do we still hesitate? I am sure the woman in this old cabinet card photo had a story to tell.

Why This Works

The abstract background provides a complex surface that stands up to the written quote. Mirroring the size and contrast of the quote with the size and contrast of the photo keeps the composition balanced. Adding washi tape in colors drawn from the painting also helps to integrate the card into the composition.

What You Need

all-purpose glue

liquid pencil (Pam Carriker's by Derivan)

old photo

prepared painted background

washi tape

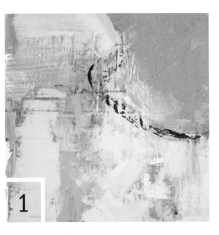

1

Recycle an old painting or painted background as a base.

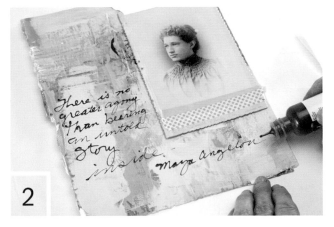

2

Place an old photo or similar item onto the base and write the quote adjacent to and around the photograph using the liquid pencil held at a slight 90-degree angle. (Test the flow before beginning!) Complete the piece by gluing the photograph in place and adding colored washi tape or similar to integrate it with the background.

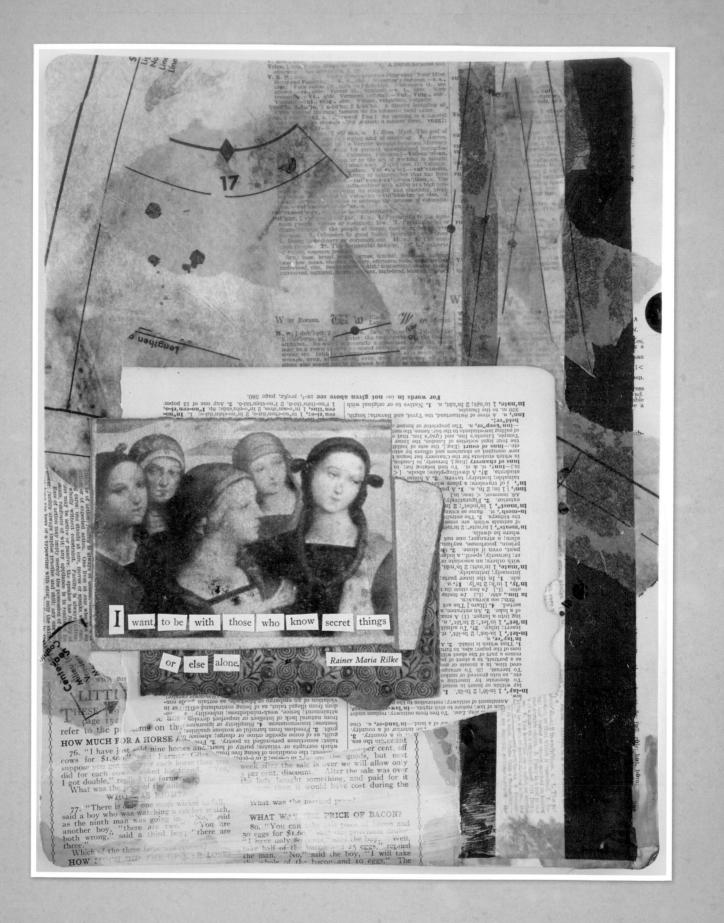

I want to be with those who know secret things or else alone.

Rainer Maria Rilke

SECRET THINGS

I want to be with those who know secret things or else alone.

—Rainer Maria Rilke

I'm not really sure why this quote pops into my head so often, but it does. (That happens to me a lot since quotes have been a part of my life for decades.) I think it relates to finding your tribe. There is nothing better than spending time with people who "get" me and my obsession with art and creativity. The only thing that I enjoy more than spending time with them is spending time alone in the studio.

Why This Works

Incorporating old papers with text into the collage works to seamlessly integrate the cut and pasted quote into the overall composition. The cut lines of the text demand our attention because of the contrast and repetition compared to the rest of the text on the page.

What You Need

glue

old book(s) or magazines

prepared mixed-media collage

scissors

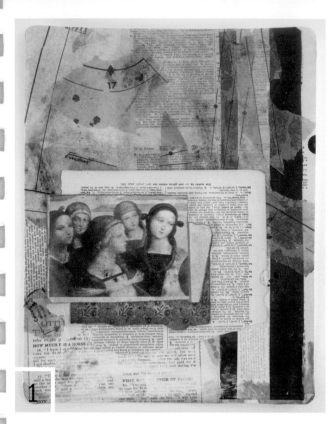

Using an old book or magazine, find and cut out the words or phrases of the quote. Feel free to vary the size and lettering by using several sources or to type and print it on your own printer.

Prepare a collage that illustrates your quote.

Trim the words and lay them out to form the quote for easy gluing.

Add glue to the back of each word and glue onto the collage in a way that adds to the overall composition.

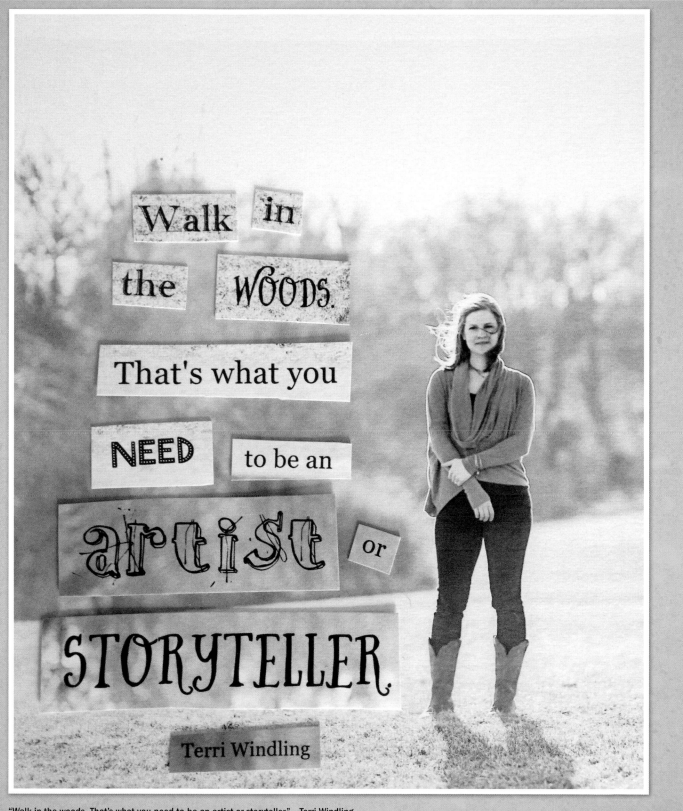

"Walk in the woods. That's what you need to be an artist or storyteller." —Terri Windling
Walk in the Woods
Lesley Riley
8" × 10" (20cm × 25cm)
Digital fonts printed on an upside-down copy of the photo, then cut and pasted onto the photo

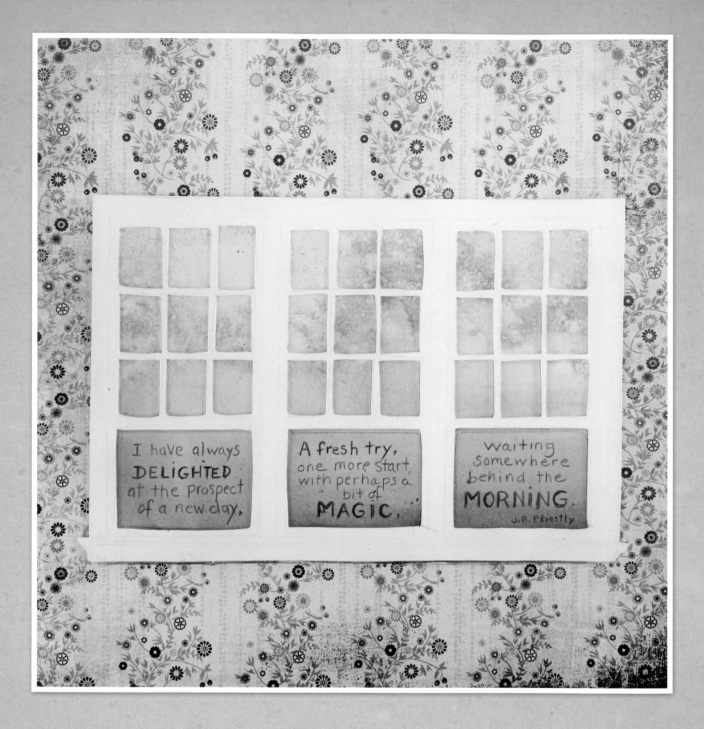

Sign up for our free newsletter at CreateMixedMedia.com.

MAGIC WAITING

I have always delighted at the prospect of a new day, a fresh try, one more start, with perhaps a bit of magic waiting somewhere behind the morning.

—J. B. Priestley

When I had an infant, three young children, a couple of teenagers, a full-time job and a burning desire to create art, I woke up every morning thinking maybe this is the day I will have some time for art. It didn't always happen but I continued to start every day that way. Still do, even though art is what I now do all day, every day. I could have just as easily chosen another favorite quote by Emily Dickinson, "Not knowing when the dawn will come, I open every door," but the image of a new day dawning inspired a window instead.

Why This Works

The quote itself has the element of repetition in its phrasing. To reinforce this I decided on a trio of windows to contain the quote. The scrapbook paper mimics wallpaper, giving the window context. The quote placement was determined by the window itself and was the obvious way to integrate quote and art.

What You Need

background paper to suggest wallpaper

colored pencil

craft knife

glue

heavy paper or cardstock

ruler

tracing paper or photocopy of image

watercolor paper

watercolors (or acrylic ink)

1

Prepare a sunrise background with watercolors or acrylic ink.

2

Using a ruler, draw or trace a window onto heavy paper or cardstock. Cut it out and cut out the openings with a craft knife. Paint as desired. Layer the window over the background and cut the background slightly smaller all around then the window frame.

3

Place a piece of tracing paper between the window and background and trace the opening onto the paper.

4

Working on the tracing paper, letter the quote and adjust for size and spacing as needed.

Place the window onto the background and with a pencil, lightly outline the three larger window openings onto the background where the quote will be lettered. Set the window aside.

5

6

Letter the quote in a color that contrasts with the sunrise but relates to the blue sky to create unity.

7

Add glue to the backside of the window frame and around each opening.

8

Align the frame on the background and glue into place.

9

Add glue to the back of the completed window/background piece and glue onto a piece of scrapbook paper or a painted background of your own that resembles wallpaper, suggesting the windowed wall where you wake to see the "prospect of a new day."

For additional downloads from the book, go to: CreateMixedMedia.com/creativeletteringworkshop.

99

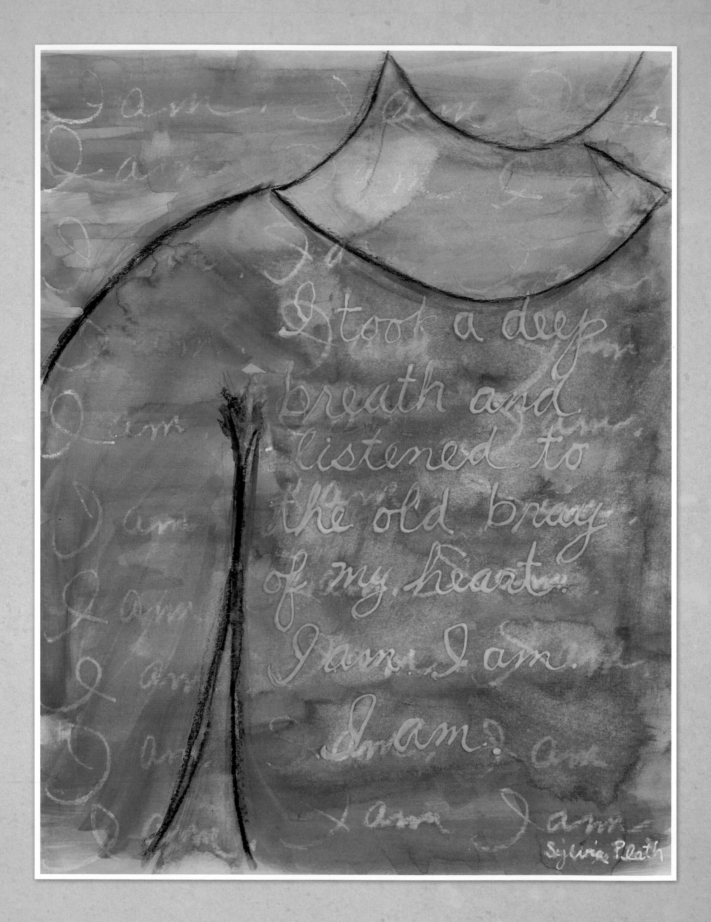

Sign up for our free newsletter at CreateMixedMedia.com.

JUST BREATHE

I took a deep breath and listened to the old bray of my heart. I am. I am. I am.

—Sylvia Plath

How often do you stop, breathe and just be? If you're like me, not often enough. It truly is the pause that refreshes.

Why This Works

I instantly knew that I would focus on the heart area. Cropping out the face and everything else not only reinforces the message and makes the heart the focal point, it becomes truly heart-centered art. The subtle layering of the background message with the crayon resist (I am. I am. I am.) creates repetition and emphasis. The contrast of a wash of darker color over the matte medium quote would make it stand out more, but I chose to keep the coloring subtle, like the quiet sound of the heart. Look and listen closely.

What You Need

crayon, white

matte medium (Golden)

mixed-media or watercolor paper

paper towel

pencil

small container

syringe, curved-tip

watercolor paints and brush

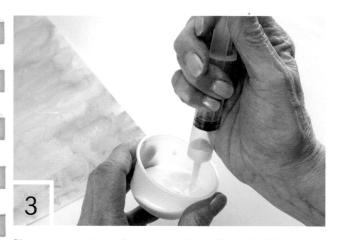

1

On a sheet of mixed-media or watercolor paper, sketch the bodice of a figure in pencil. Write a word or phrase from the quote repeatedly over the figure using a white crayon.

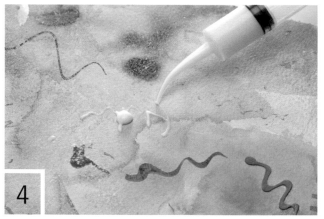

2

Add a thin layer of paint over this layer to bring up the written text. Let dry.

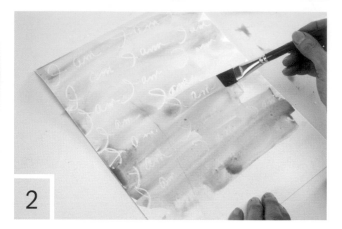

3

Place some matte medium in a small cup. Push all of the air out of the curved-tip syringe. Place the syringe into the tilted cup and draw back the plunger to fill the syringe with the medium. One-quarter to half full is plenty.

4

Grasp the syringe with the plunger in the palm of your hand and with your fingers around the rim. Push out any air bubbles and get a feel for the flow by writing onto scrap paper. Gently pull the syringe toward your palm to extrude the medium.

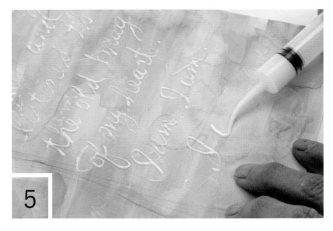

5

Write the full quote onto the bodice over the previous crayon writing. Allow the medium to fully dry.

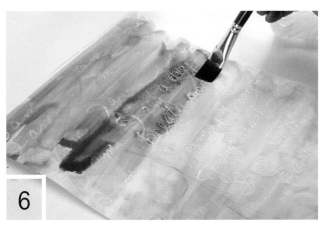

6

Add another layer of darker or contrasting paint onto the page.

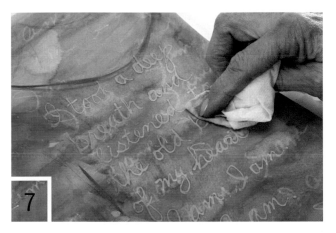

7

Gently wipe off excess paint from the matte medium lettering with a damp paper towel before the paint dries.

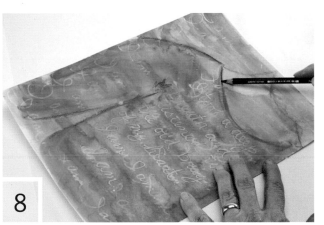

8

Go back in and darken your sketch, adding any more color or definition as desired.

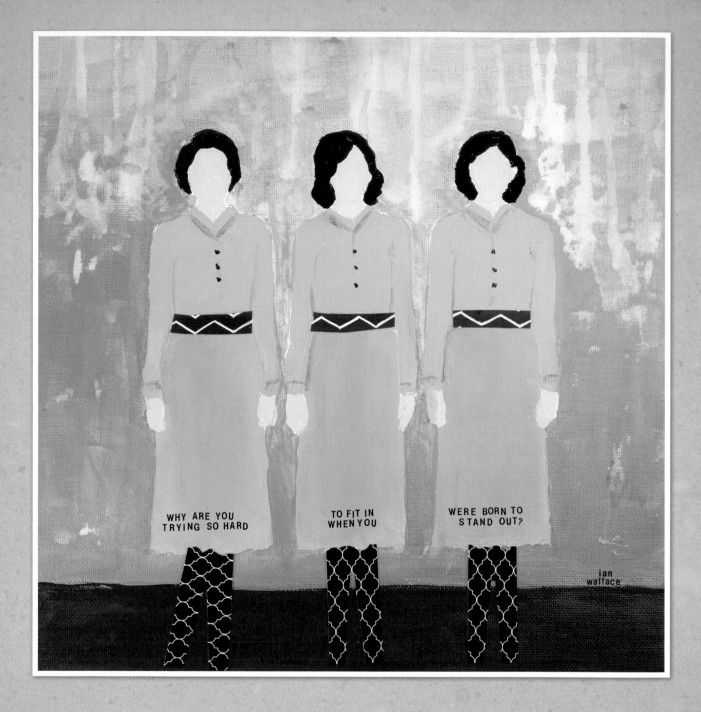

PROJECT 19

STAND OUT

*Why are you trying so hard to fit in when
you were born to stand out?*

—Ian Wallace

This is a question I ask myself often. Did you know that we are evolutionarily programmed to conform, to fit in with the herd as a survival mechanism? It's an instinct we fall back on when we are afraid of doing anything new. We don't want to stand out or be noticed. It takes courage to be seen, take the lead and make a difference. I give my courage muscle a workout every day.

Why This Works

By now you should see how powerful repetition is in conveying a message. I used the principles of repetition, balance, scale and harmony with the elements of shape and color blocks to emphasize the message of the quote. Keeping the faces blank reinforces the anonymity of being part of the crowd.

What You Need

burnishing tool

decorative paper (optional)

painted background

pencil

rub-on transfer letters

tracing paper

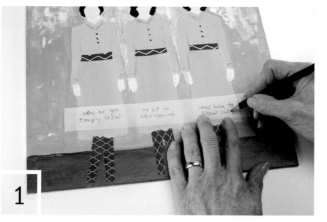

1

2

Prepare a painted background for the quote. (I painted figures over a background and used decorative paper for the figures' belts and stockings.) Place a piece of tracing paper over the area where you want the quote to be and pencil in the lettering to determine spacing.

Following your guide, apply the quote to the painting by burnishing the rub-on letters one-by-one. When finished, cover with tracing paper and burnish the entire quote again to ensure good adhesion.

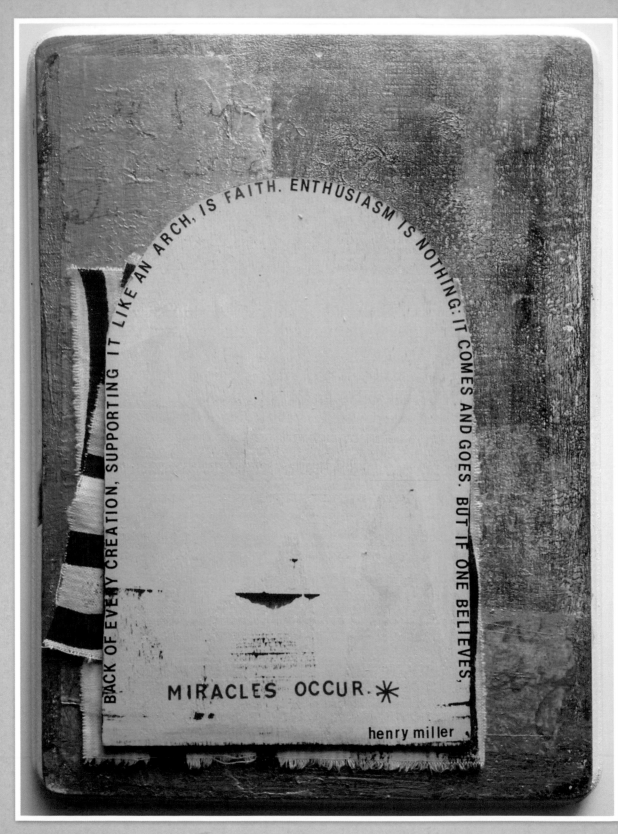

"Back of every creation, supporting it like an arch, is faith. Enthusiasm is nothing: it comes and goes. But if one believes, then miracles occur." —Henry Miller
Miracles Occur
Lesley Riley
7" × 9" (18cm × 23cm)
Paint, fabric, Letraset and Archer rub-on transfer letters on wood

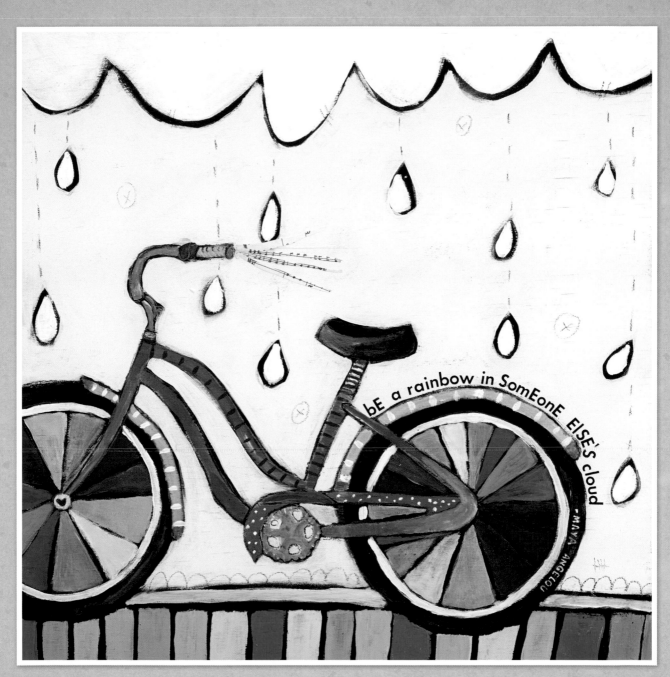

"Try to be a rainbow in someone's cloud." —Maya Angelou
Rainbow Bike
Jenni Adkins Horne
12" × 12" (30cm × 30cm)
Acrylic and collage on wood

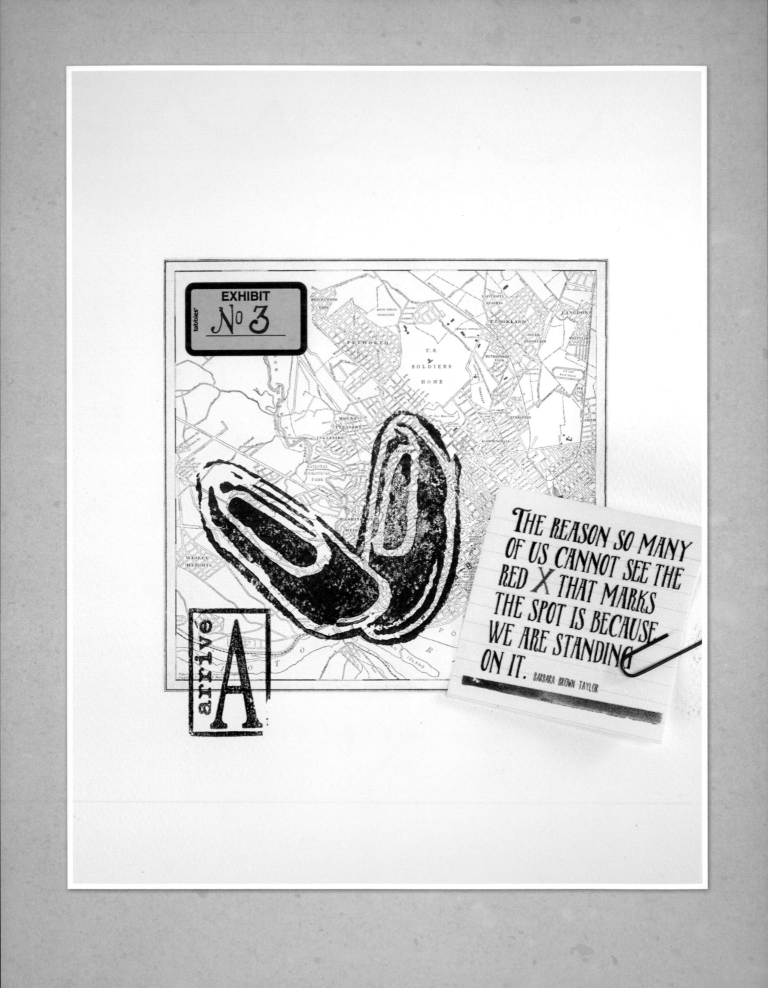

X MARKS THE SPOT

*The reason so many of us cannot
see the red X that marks the spot
is because we are standing on it.*

—Barbara Brown Taylor

Just like the diamond necklace in *Diamond Girl*, what you are looking for is usually right under your nose. It's hard to know you have arrived when you are constantly looking at where you have been or where you want to go. This quote is a reminder to me to enjoy the present and remember that my future is created in each and every present moment. Be here now. To pull the story together, I used a TAP transfer of a vintage map of my hometown, my hand-carved shoes stamp and the Arrive stamp as a reminder that I am already here.

Why This Works

The use of red throughout keeps the eye moving through the composition. The large red stamp and the attached quote balance each other and create impact to deliver the message. Do you see the repetition of shape in this piece?

What You Need

embellishments

index card or cardstock

iron/ironing surface

paper clip or glue

prepared background

TAP Transfer Artist Paper

1

Prepare a background for the quote.

2

Using a quote preprinted (in reverse) onto TAP Transfer Artist Paper, place it quote-side down on an index card or cardstock.

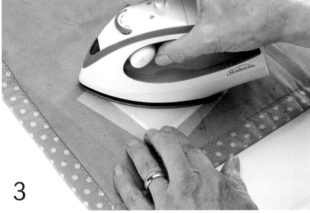

3

Using a hot dry iron on a firm ironing surface, iron the TAP for six to ten seconds until the quote transfers onto the card.

4

Peel the TAP paper away while hot to reveal the transferred quote. Trim as desired and paper clip or glue in place onto your artwork. Embellish further as you like.

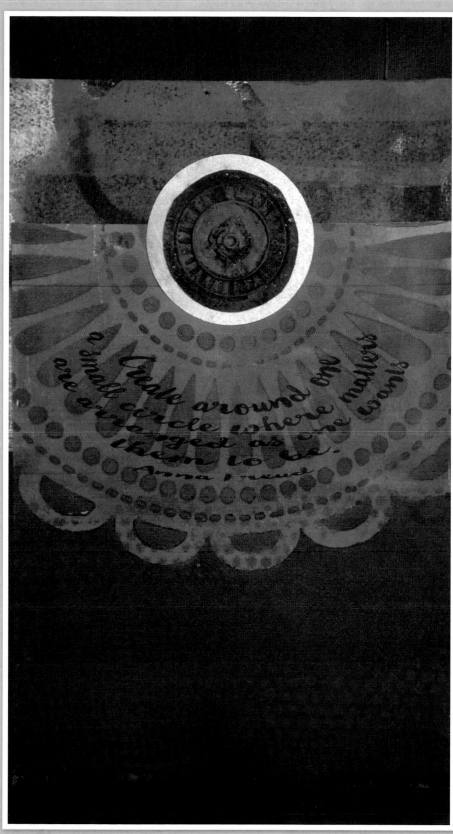

"Create around one a small circle where matters are arranged as one wants them to be." —Anna Freud
Around
Lesley Riley
8" × 14" (20cm × 36cm)
TAP transfer of text onto stenciled, painted and collaged watercolor paper

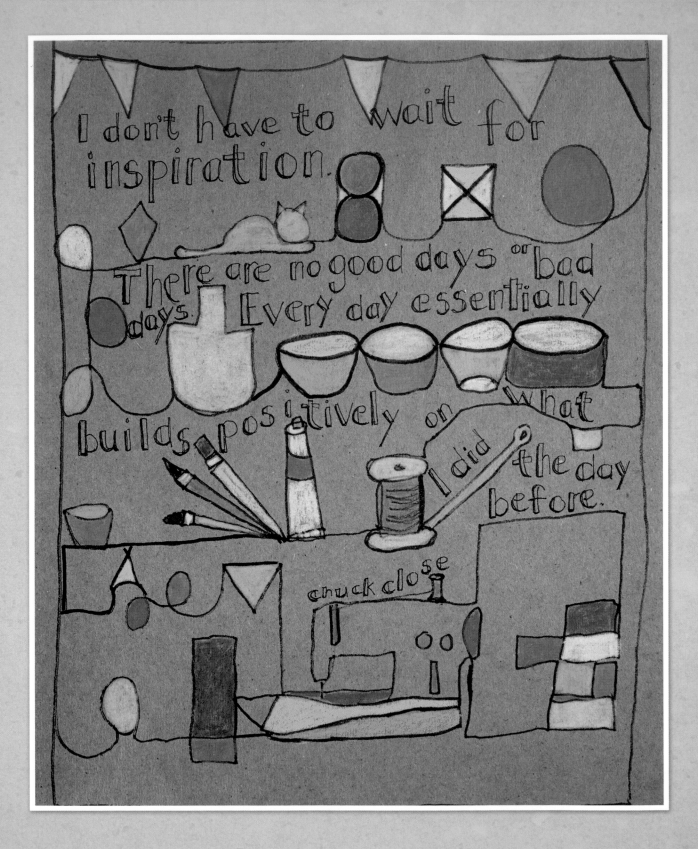

THE DAY BEFORE

*I don't have to wait for inspiration. There are
no good days or bad days. Every day essentially
builds positively on what I did the day before.*

—Chuck Close

This piece was a doodle sketch inspired by Diane Culhane's "taking a line for a walk" exercise. There was no plan or thought on what to draw or include once I started. When finished, I realized how the idea of taking a line for a walk mirrors how we travel through our days. When I noticed that I included art and sewing in the piece, it made me think of this quote. Doing just a little bit of art every day does lead to building an art-centered life. Ask me how I know!

Why This Works

The black line guides and leads the eye through the piece, telling a story as it changes shape and form. The use of color draws attention to familiar shapes and the story. Adding the quote in much the same way, having it travel through, around and in between the color and shapes, creates a sense of integration, balance and belonging.

What You Need

black marker, fine-tip (for decorative lettering)

colored pencils

kraft paper

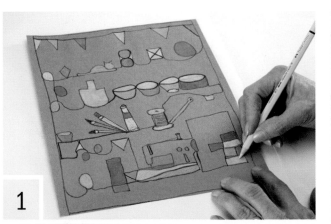

1 Create a black line drawing and color in the shapes.

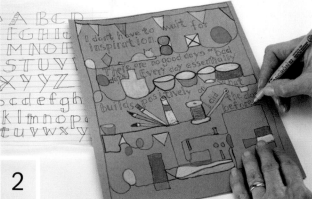

2 Hand-letter the quote in an open font using a black pen to complement and emphasize the lines in the drawing.

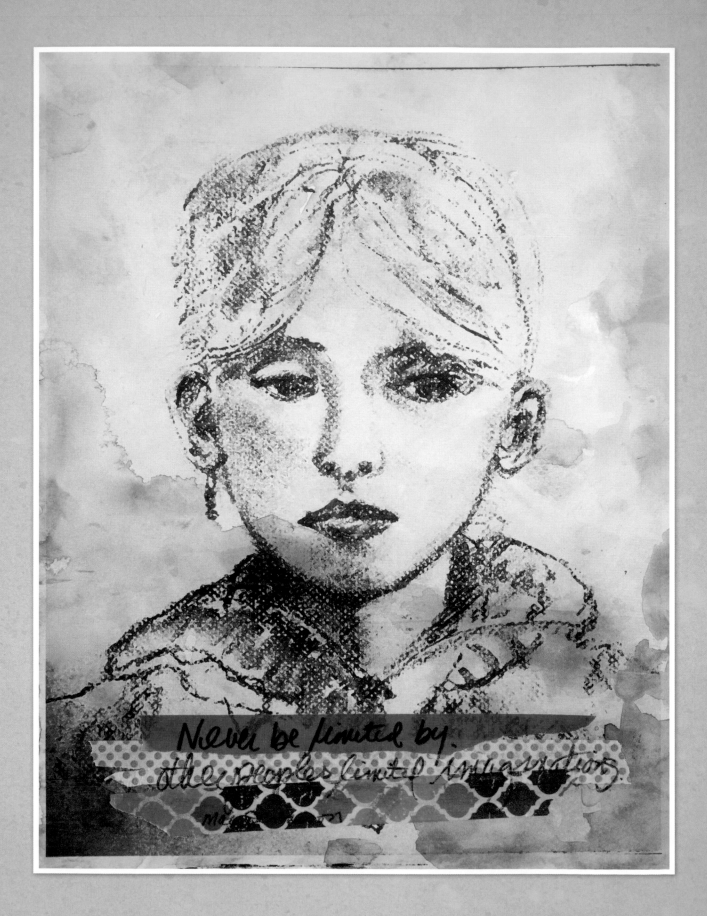

LIMITS

Never be limited by other people's limited imaginations.

—Mae Jemison

The original of this drawing hangs in my studio as a constant reminder that, yes, I can draw portraits. Of course I know that, but when I start looking at everybody else's art, I tend to forget. I can draw portraits, I want to draw portraits, but I don't because it takes me a lot of time to get it right. I know the only thing standing between me and getting better at it is my own limited imagination and a lot of practice. What's limiting you?

I took a photo of my drawing, altered it in Adobe Photoshop and printed it on a piece of mixed-media art paper painted with watercolors. The addition of washi tape adds pattern and creates a set of lines that are the perfect place to add a quote. Plus, you can remove or switch the tape and add another quote at any time!

Why This Works

Line and color are the tools used to connect word and image in this simple illustration. The punch of bright pink and the pattern in the bottom piece of washi tape add just enough contrast and variety to create interest and draw our attention away from her gaze and to the quote below where the writing itself appears as a pattern at first glance.

What You Need

photocopier or printer

Pigma Micron Graphic Pen 01 (blue)

prepared watercolor background

washi tape

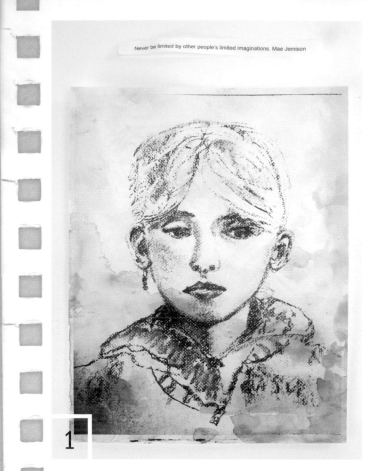

1

Copy a black-and-white drawing onto a sheet of painted water-color paper.

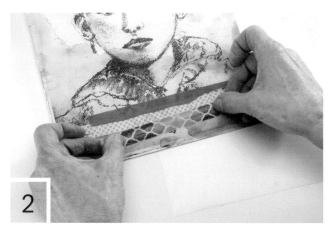

2

Add washi tape to the print.

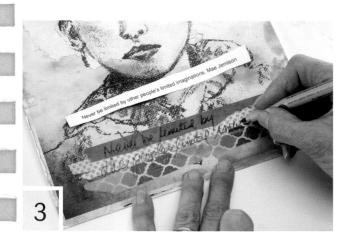

3

Choose a pen or marker that will not smear on the washi tape (test first!). Write the quote on the tape.

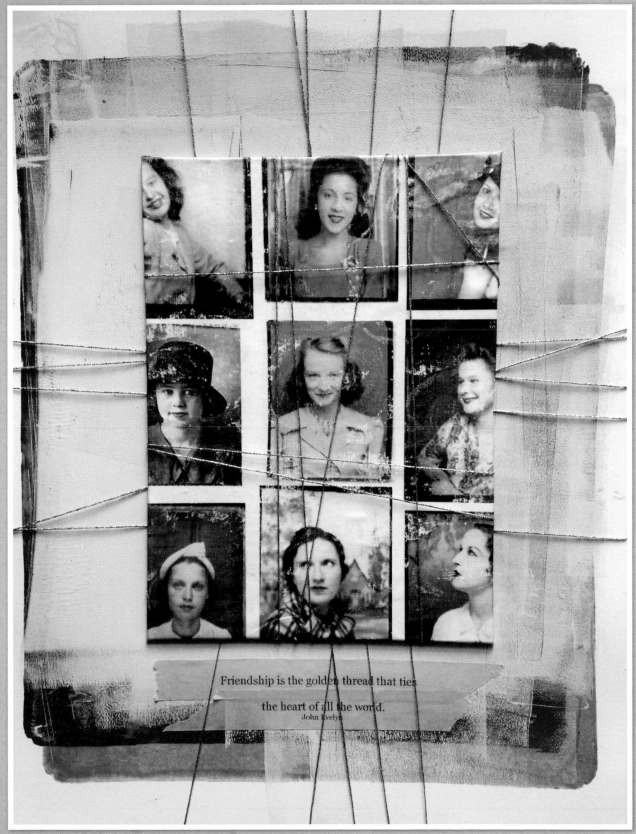

"Friendship is the golden thread that ties the heart of all the world." —John Evelyn
Golden Thread
Lesley Riley
9" × 12" (23cm × 30cm)
Mixed-media collage and quote printed onto washi tape on mixed-media paper

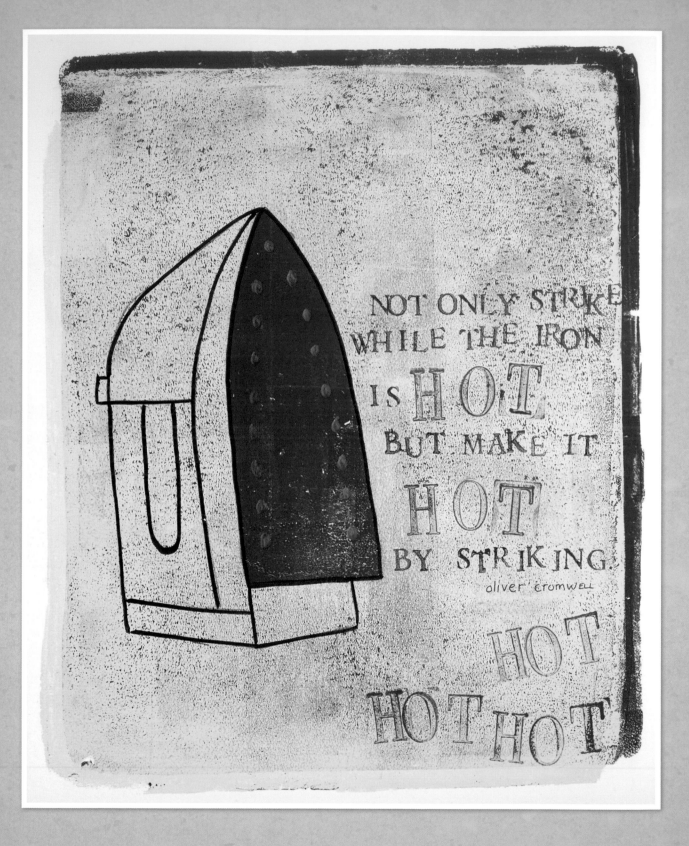

HOT! HOT! HOT!

Not only strike while the iron is hot but make it hot by striking.

—Oliver Cromwell

It is important to take action toward creating the results you want, rather than sitting back and waiting for them to happen on their own, a sentiment Cromwell expressed in a quote that inspires a strong visual image that I couldn't wait to create on my Gelli Plate. By combining regular and reverse rubber stamps, it was the perfect short quote for Gelli Plate stamping.

Why This Works

A limited palette and the change in scale of the stamped letters draw attention to the message of the quote. Placing the quote next to the red focal point and keeping it a similar size ensure that the message will be read. Repeating the word *HOT* at the bottom adds movement and variety to an otherwise static composition.

What You Need

acrylic paint and brush

alphabet rubber stamp set

alphabet rubber stamp set, reverse

black marker

brayer

eraser

Gelli Plate

graphite paper

image of an iron

ink pad

mixed-media paper (Strathmore)

Open Medium (Golden)

scrap paper

1

Use the Gelli Plate to print a solid red background.

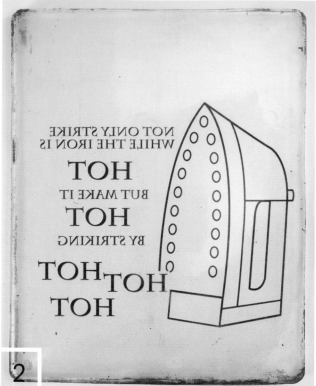

2

Work out your spacing by hand or on your computer and print or copy it *in reverse*. Slip this under the Gelli Plate as a guide. Cut a mask from scrap paper to place over any areas you wish to remain red after future printing.

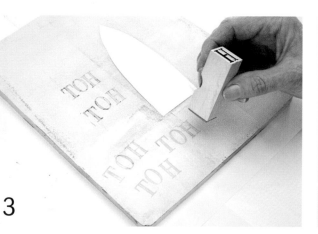

3

Mix white acrylic paint with Open Medium and brayer over the plate. Using your guide, stamp the T O H letters of the quote. Remember that you are stamping words in reverse. Place a mask over the area of the iron that you wish to remain red.

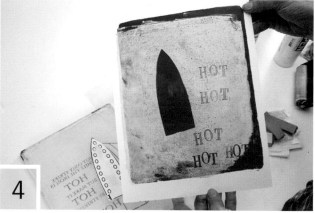

4

Place the red paper onto the plate and burnish with your hands or a brayer. Lift up to reveal the print. Let dry.

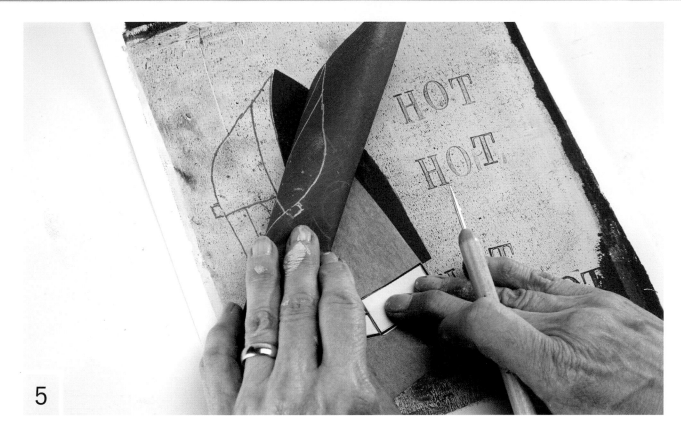

5

Transfer the lines of the iron onto your piece with graphite paper. Go over the transferred lines with a black marker and erase the graphite as much as you can.

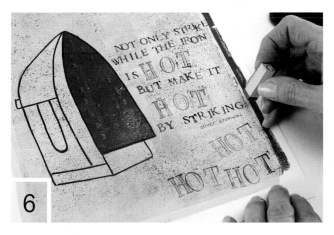

6

Stamp the remainder of the quote onto the page. Practice spacing on a scrap piece of paper if needed.

5 TIPS FOR SUCCESS

1. Don't try to letter an entire quote. Emphasize the message by stamping just the key words.

2. Mix Open Acrylic Medium or retarder with your paint or use Open Acrylics and work quickly.

3. Lay out the alphabet stamps in reverse order before adding paint to the plate. For example, to stamp the phrase "go for it," lay out the stamps in this order: TI ROF _ G. After using the letter O, lay it down in the space left before the G so the word *GO* is ready to go.

4. Most important! Remember that you are stamping words in reverse. If paint obscures your guide, place another reverse stamping guide next to your work area for reference.

5. Make a mistake? No worries. Just brayer over the paint and start over, or if the paint has dried too much, pull a print to clean the plate and start with fresh paint and medium.

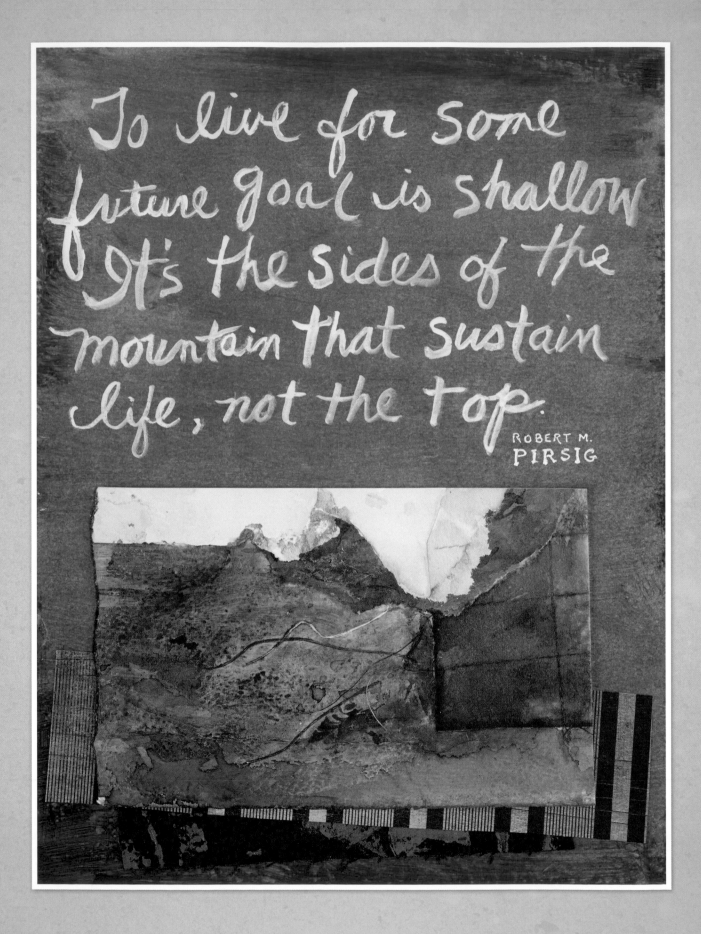

To live for some future goal is shallow. It's the sides of the mountain that sustain life, not the top.

ROBERT M. PIRSIG

SUSTAIN LIFE

To live for some future goal is shallow. It's the sides of the mountain that sustain life, not the top.

—Robert M. Pirsig

It's the journey, not the destination. Stop and smell the roses. Be here now. How often do we need to be reminded to enjoy the present moment rather than be always looking for the next best thing? This illustrated quote was inspired by a fragment of a larger mixed-media collage that reminded me of a mountain. It led me to search for just the right quote.

Why This Works
Notice how your eye bounces back and forth between the quote and the art. The placement and scale of both, in combination with a brilliant blue background tying them together, balance and create a cohesive piece. The addition of red adds the necessary pop of color to create variety and interest, while the vertical lines in the striped paper contrast with the strong horizontal shapes of the quote and image.

What You Need

all-purpose glue

chalk pencil, white

collaged art remnants

gel pen, white (Uni-ball Signo)

mixed-media paper

paper towel

water brush

watercolor, opaque white (Dr. Ph. Martin's Bleed Proof White)

1

Paint a wash of acrylic on mixed-media paper. Let dry. Sketch out the quote with a white chalk pencil.

2

Using opaque white watercolor and the water brush, write over the chalk words. Let the watercolor dry. Wipe away the chalk lines with a dry paper towel.

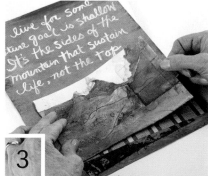

3

Write the quote's attribution in white gel pen. Collage the art, paper and fabric onto the bottom of the piece with glue. Let dry. Placing the piece under a stack of books will ensure that it adheres well and dries flat.

ADDITIONAL INSPIRATION

The purpose of writing a book is to share what you know and love. It is always a labor of love.

One of the best parts (maybe *the* best part) of creating a book is including art from other artists I know and love. I am always curious about where art comes from and how other artists create. Seven of the seventeen artists who contributed art for this book have generously shared not only their art, but techniques, inspiration and insight into their process.

I wanted to include their invaluable, in-depth information so you will have a variety voices to inspire and inform you. You never know where you will find your next *aha* moment.

Specializing in the Impossible
11" × 14" (28cm × 36cm)
Mixed media, acrylic, ink and crayons on cradled wood panel

Sign up for our free newsletter at CreateMixedMedia.com.

CHERYL BAKKE MARTIN

What we need is more people to
specialize in the impossible.

—Theodore Roethke

What steps did you take to arrive at your concept for illustrating your chosen quote?

This was partly influenced by the technique. I knew that the process would be driven by this specific lettering process. Lately I've been painting dancers, and the image of a dancer flying through the air seemed to fit perfectly with the quote. So the image and the lettering process began forming the early concept in my mind.

Briefly describe how you created the art.

I painted the underpainting first: An abstract full of symbols and marks painted purely following my intuition. This part of the process is purely play—layering with bright colors, shapes and marks.

The quote is lettered with masking fluid and a brass pen with a flat nib. And I also masked the shape of the figure with paper that I had cut out.

With all the areas protected, I painted the blue-green background. Once the background was dry, I lifted the masking fluid and peeled off the paper, revealing the letters and the dancer. I used water-soluble crayons to add shading to the dancer.

The final step: Pen work on both—rough outlines in several colors to give it a sketchy, graffiti-like feel.

At what part of the process was the quote added to the piece?

Because I had to preserve the underpainting to reveal the letters, it was a bit difficult to fit the quote and the figure together. The letters needed to be quite thick so the background design showed through. I also considered the values so the letters would be lighter against a dark background, which also helped to ensure they would show up. Compositionally, this was tricky because both the figure and the letters are a focus.

Please list the materials you used to add the quote to your art.

I used acrylic paint on a wood panel, masking fluid, glitter spray, Lyra water-soluble crayons, Sharpie paint pens and Derwent Inktense pencils.

Do quotes play a regular part of your art or life?

Yes, always. I have a hard time *not* putting words into my work. I began learning calligraphy in high school because I wanted to create inspirational posters for my room. I spent days in the library going through past issues of *Reader's Digest*, writing out quotes to use. I haven't stopped since.

I have quotes all over my studio and house. I am always looking for easy ways to include words of support, love and inspiration in all of it.

What one thing would you say most inspires your art?

My spiritual practice. What I create is often a result of me being in a quiet space, reading or listening to various teachers, and what I am studying influences the topic I choose to illustrate. What I am working through personally and where I most need comfort and support are often the source of the words or quotes that end up in what I am creating. I know that whatever I am going through in my life, others most certainly are too, and I seek to share that comfort and inspiration with others.

Artist Bio

Cheryl Bakke Martin is a lifetime artist. Her dad tells the story of her first pair of earrings made at age three! Through a lifelong love, appreciation and study of the arts, she has found her own personal renewal in the studio, and she delights in sharing that experience with others. Her current active works include finished jewelry, paintings, illustrations and wall sculptures that combine blacksmithing and other metalwork, colored pencil, acrylic painting, flame-worked glass and beadwork. She currently provides creative instruction and inspiration through retreats and an online publication called *Wine, Women and a Paintbrush: Creative Inspirations and Adventures for Women*.

www.inspirations-studio.com

www.winewomenandapaintbrush.com

Eyes Turned Skyward
8" × 8" (20cm × 20cm)
Mixed-media collage on wood panel

Sign up for our free newsletter at CreateMixedMedia.com.

CAITLIN DUNDON

Once you have tasted flight, you will forever walk the earth with your eyes turned skyward, for there you have been, and there you will always long to return.

—**Leonardo da Vinci**

What steps did you take to arrive at your concept for illustrating your chosen quote?

I have been working lately on the "put a bird on it" theme and variations thereof. I have been photographing birds lately, and crows certainly abound in my neighborhood. This crow sat still for me long enough to get a good photo. I have been searching for beautiful quotations that relate to birds, something I didn't already have in my collection except for the classic Emily Dickinson "hope" quote.

Briefly describe how you created the art.

I like to work on wood panel or paper rather than canvas, as I like to use a calligraphy pen a pointed pen and need a fairly smooth surface or the nib will catch on the surface. This crow is on deep-cradled birch wood panel. I apply white gesso in several coats, sanding a lot. Sometimes I use photo transfers or hand-paint my imagery, but in this case I used a simple ink-jet print on regular ink-jet paper and collaged him into my work, touching up his feathers just a bit with a light wash of paint. The background is collaged with tissue paper and old novel text and layers of gesso and paint with a little bit of textural marks made by hand in the grass.

At what part of the process was the quote added to the piece?

I have been working with quotations and words in my art for more than eighteen years. Sometimes I do start with layers of script, but usually it is the final process after I have imagery, color and collage on my substrate. I am always aware and leave space for the words, sometimes putting them over the imagery, but in this case I like the bird breaking into the script. Sometimes I have an exact quote in mind but not always. I will do a rough sketch of the script on tracing paper, but it always ends up being different on the final art. The words have a mind of their own and seem to fit into the space in a natural (very non-computer) way and things just come together magically. There are times I just have to have trust, not even drawing guidelines for the writing.

Please list the materials and steps you used to add the quote to your art.

After I was happy with the background colors of the painting, I sanded with slightly rough sandpaper and then added a Quinacridone Nickel Azo Gold glaze to fill in any white that had been sanded off. I then used very fine sandpaper to make the surface smooth. I used a Nikko G nib in a straight penholder and Golden High Flow acrylic to create the lettering. I had to be extremely careful with the nib near the edge of the collaged papers. I really love the thick and thin lines that result from using pointed pen nibs that a Pitt pen or Micron would not allow.

What one thing would you say most inspires your art?

I am definitely inspired by words like *dream* and *believe* and *trust*, as that's what I have had to think about and focus on, not just to become an artist, but to keep being an artist and to make a living as an artist. I am also very inspired by nature, other artists and just what happens when paint touches paper and gesso and gel and the magic happens.

Artist Bio

Seattle artist Caitlin Dundon is known for her trademark handwritten script and use of inspirational words in her mixed-media paintings. She is a professional calligrapher and instructor in both mixed-media collage techniques and pointed pen calligraphy. Her work has been featured in *Letter Arts* magazine, *Somerset Studio, Somerset Place, Seattle* magazine, *Seattle Bride* and *Manhattan Bride*. Her art is in the collections of Oprah Winfrey, Elton John and Prince Andrew, Duke of York. Dundon is also a licensed artist; her work has been reproduced as prints, greeting cards, fabric and other items in the home décor market. www.oneheartstudio.com

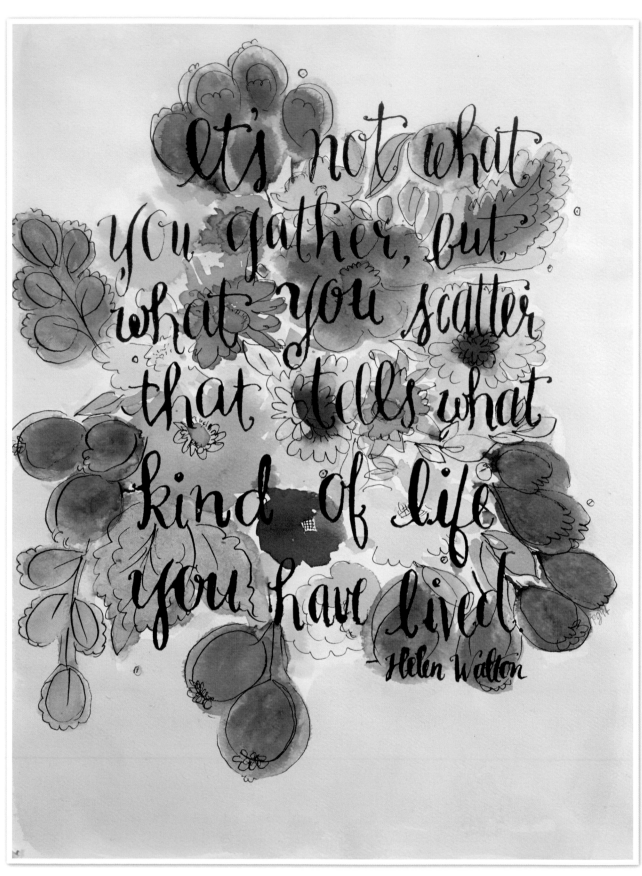

It's not what
you gather, but
what you scatter
that tells what
kind of life
you have lived.
– Helen Walton

What Are You Gathering?
9" × 12" (23cm × 30cm)
Watercolor and ink on paper

PAM GARRISON

*It's not what you gather, but what you scatter that
tells what kind of life you have lived.*

—**Helen Walton**

*What steps did you take to arrive at your concept for illustrating
your chosen quote?*

I thought about the quote, its meaning and the intention it
holds. Words like *abundance, beauty, miracles, love, generosity,
faith* and *nature* came to mind. It reminded me of a saying
from Victorian times, "May life's fair flowers around you
fall," and tying it all together, I decided to scatter flowers as
a background for the lettering of the quote.

Briefly describe how you created the art.

I dropped and brushed watercolor paint onto watercolor
paper, letting the watercolors take an organic path fitting
for nature's flowers. I used a fine black pen to add a little
bit of detail to the leaves and flowers. After letting the
watercolors dry overnight, I used a dip pen and ink to write
the quote on top of the flowers.

At what part of the process was the quote added to the piece?

At the end. The background art is meant to complement
the quote as a background.

How did it figure into the composition?

I wanted the quote to stand out, so I centered it loosely on
top of the artwork, using black ink for the highest contrast.

Was it difficult to combine art and text?

No, I love quotes and lettering and text on top of art.

*Please list the materials and steps you used to add the quote to your
art.*

I used a dip pen with a G nib and black calligraphy ink to
write the quote. I don't worry about perfection, instead
wanting the handmade nature of the lettering to be apparent, so I just eyeball the lines and spaces.

Do quotes play a regular part of your art or life?

Yes, I often write quotes in my art journals and on any scrap
of paper I can find when I run across one to use later. They
are a welcome avenue to thinking through someone else's
thoughts and concepts and often inspire me to think differently or take a slightly different approach.

Please share a favorite quote of yours.

I've been struggling with time management and the endless to-do list, so this quote hit home:

> *The key is not to prioritize what's on your schedule, but to schedule your priorities.*
> —Stephen Covey

What one thing would you say most inspires your art?

Colors and the combination of them, how they play off
each other and change the tone depending on their play
off each other.

Artist Bio

Pam Garrison is an artist and crafter living in Southern
California with her husband and two kids. She's wildly passionate about the pursuit of creativity and hopes to inspire
others to create by following her artistic desires and sharing
those pursuits. She believes in following whatever path her
art interests take her; lately, that's art journaling, abstract
painting and hand-weaving. She teaches various art classes
at home and abroad, is published in numerous art books
and magazines, and writes about her creative adventures on
her blog.

www.pamgarrison.com

Our Daily Lives
6" × 9" (15cm × 23cm)
Encaustic mixed media on wood panel

BRIDGETTE GUERZON MILLS

What is the good of your stars and trees, your sunrise and the wind, if they do not enter into our daily lives?

—E. M. Forster

What steps did you take to arrive at your concept for illustrating your chosen quote?

When I began this piece I went through my photos and pulled out images that I felt spoke to the imagery listed in the quote: Sunrise, tree and sky. I started with a sunrise, but felt that it was too literal. I realized at this point that while I work with quotes often, choosing the quote is always at the end of the creation.

I decided to just explore and create. I turned to my tree and bird imagery, and the process flowed much better. Creating the grid at the top became my symbol for a calendar and the turning of days and seasons.

The writing in the first grid square speaks to journaling. Journaling is a way for me to slow down and notice the world around me. The bare winter tree is always my symbol of self.

To create this piece I drew from my own visual symbols and language that I've developed through the years. I kept the quote in the back of my mind during the creation, holding the meaning close to me while trying not to be too literal.

At what part of the process was the quote added to the piece?

The quote was the final addition to the panel. I really had only one choice of where to put the quote, which was at the bottom. I played around with scratching the words into the wax, as well as painting the words on top of the wax with India ink. In the end, I chose to write the quote onto fabric with a graphite pencil and added that on top.

It was difficult to add the quote to the piece. It took many trials until I felt that it looked like a cohesive piece. I felt that the cloth on the bottom echoed the cloth bits at the top of the panel and reinforced the feeling of a quilted painting.

Please list the materials and steps you used to add the quote to your art.

To add the quote, I chose a torn cloth napkin. I wrote the quote on the cloth with graphite pencil and sewed lines underneath the writing using thread and needle, the latter giving the idea of lined paper and adding more texture. Gently heating up the wax surface with a heat gun, I then pressed the cloth onto the panel. To further secure the cloth, I wrapped the fabric over the edges and, using gel medium, adhered the cloth to the back of the wood panel.

Do quotes play a regular part of your art or life?

Words have always been magical to me. I have always loved quotes and keep separate journals that house only quotes that I encounter. When I write on my blog, I often find a quote to go along with my entry.

I have created a whole series of paintings based on one stanza of a single poem and have created artist books based on an image of a single scene described in a novel. Words are powerful and often inspire my creative process. Some quotes can sustain us and give us hope. They can be prayers.

Please share another favorite quote of yours.

We are cups, constantly and quietly being filled. The trick is, knowing how to tip ourselves over and let the beautiful stuff out.
—Ray Bradbury

What one thing would you say most inspires your art?

The powerful mystery of nature.

Artist Bio

Bridgette Guerzon Mills is an award-winning artist who has exhibited her work nationally and internationally. Her artwork is a personal dialogue that reaches into the stillness and spirit of the natural world. Through both imagery and medium, she creates organic pieces that speak to the cycles of life, memory, longing and the passage of time. Her work incorporates a variety of mediums including photography, encaustic and salvaged materials. Her work has been published in magazines and books and has been collected in the United States and abroad. She currently resides in Towson, Maryland with her family.
www.guerzonmills.com

What's the Use of Worrying?
6" × 8" (15cm × 20cm)
Mixed-media journal page, paper, acrylic paint and thread on paper

Sign up for our free newsletter at CreateMixedMedia.com.

JESSICA HERMAN GOODSON

What's the use of worrying? It never was worthwhile, so, pack up your troubles in your old kit-bag, and smile, smile, smile.

—George Asaf

What steps did you take to arrive at your concept for illustrating your chosen quote?

I wanted this piece to be a personal reminder for myself, so I chose to turn it into a mixed-media self-portrait.

Briefly describe how you created the art.

This piece began with layers of paint, stencilling and mark making over vintage book pages. I then added a little stitching and began a rough sketch of the figure and lettering in the negative space. Building upon that sketch, I added paint to the face and shirt, choosing to leave the stencilled texture showing through the hair. Next came painting the words in both script and block letters. The final touch of the piece was line work to define the illustration as well as to outline the text.

At what part of the process was the quote added to the piece?

Text was incorporated into this journal page about midway through. I had already created a thumbnail sketch of the piece, so I had an idea of where I wanted the words to go. When I letter, I often spontaneously decide which words will be script and which will be more blocky.

Please list the materials and steps you used to add the quote to your art.

Words were added to this piece loosely at first using pencil. Next I used a fine brush and white acrylic to paint and refine the lettering. The final step was to outline or add shadows to the letterforms using either a pen or extra-fine paintbrush and acrylic.

Do quotes play a regular part of your art or life?

Quotes often make their way into my journal pages and mixed-media paintings. A powerful quote can serve as a reminder of lessons learned or obstacles still to tackle. Text is a significant part of my work, and I allow it to be just as important as the imagery.

I incorporate quotes into my visual journals, jot them in my daily calendar and make hand-lettered paintings.

Please share another favorite quote of yours.

What you seek is seeking you.

—Rumi

What one thing would you say most inspires your art?

My personal life inspires my work first and foremost. This encompasses a range of things from my own experiences, travels, nature and the world around me as I see it.

Artist Bio

Jessica Herman Goodson is a mixed-media artist and maker of books who lives in Boulder, Colorado. Enamored with all things paper, she spends her time collecting bits of flotsam and jetsam, making pictures with her trusty Diana camera, carving stamps, sewing on paper and fitting it all into her visual journals. With a B.F.A. and background in graphic design, she continues to merge typography, illustration and graphic elements with the more organic processes of painting, drawing and collage. Jessica's work appears in *Pages* magazine, *Art Journaling* magazine and *Somerset Studio* as well as in the books *Real Life Journals*, *No Excuses Art Journaling*, *Map Art Lab* and *A World of Artist Journal Pages*. www.jessiestarling.blogspot.com

Untitled
9" × 12" (23cm × 30cm)
Acrylic, pastel, charcoal and ink on paper

KATIE KENDRICK

I am in the mood to dissolve into the sky.

—**Virginia Woolf**

What steps did you take to arrive at your concept for illustrating your chosen quote?

My first step was to write the quote out in my own hand as well as put it to memory. The thing that stood out to me initially was color. I knew a deep blue sky would be a prominent feature in the painting along with the subject, a woman. I had only a loose idea; the rest I knew would just flow once I got started.

Briefly describe how you created the art.

I assembled acrylic paints, collage papers, colored pencils, charcoal and a pen. I glued pieces of collage papers down randomly, but also ones that I was attracted to because of their color, line or pattern. I painted a blue sky background on top of the collage, using white and black to darken and lighten areas. The woman was the next to appear, her orientation slightly tilted, and I used paint, charcoal, collage and colored pencils. I drew houses and buildings below her followed by the quote.

At what part of the process was the quote added to the piece?

I added the quote at the very end of the process so I could integrate it into the painting. I decided that I wanted it to coil out from the center of her belly, the "second brain" of the body, as the quote represented a thought that was coming from her intuitive center rather than her intellect. It wasn't difficult to combine them when I made the decision to keep the text very small, something that the viewer could only see after they'd look at the painting more closely.

Please list the materials and steps you used to add the quote to your art.

I used the simplest of materials, a black Faber-Castell Pitt pen. I wrote the quote small and in my own hand.

Do quotes play a regular part of your art or life?

Yes. I have particular quotes that serve as compact power sources for me, ways to remind myself what is important to me and keep me inspired, encouraged and on the right path. When I teach classes, I like to use quotes to guide and inspire participants in their art making.

Please share another favorite quote of yours.

A bird doesn't sing because it has an answer, it sings because it has a song.

—Maya Angelou

What one thing would you say most inspires your art?

Being in touch with my passion is the heart of my inspiration; when I'm in touch with that, everything flows. To stay in touch with my passion I practice listening to my intuition and try to discover and follow what brings me joy in life.

Artist Bio

For over thirty years, Katie has lived along the Tahuya River in western Washington, surrounded by wildlife and a beloved enchanted forest. Besides her art, she has a passion for gardening, and she and her husband grow much of their own food on their seven-acre farmette. She teaches painting and creativity workshops in the U.S. and internationally and plans to offer online classes in the near future. www.joyouslybecoming.typepad.com

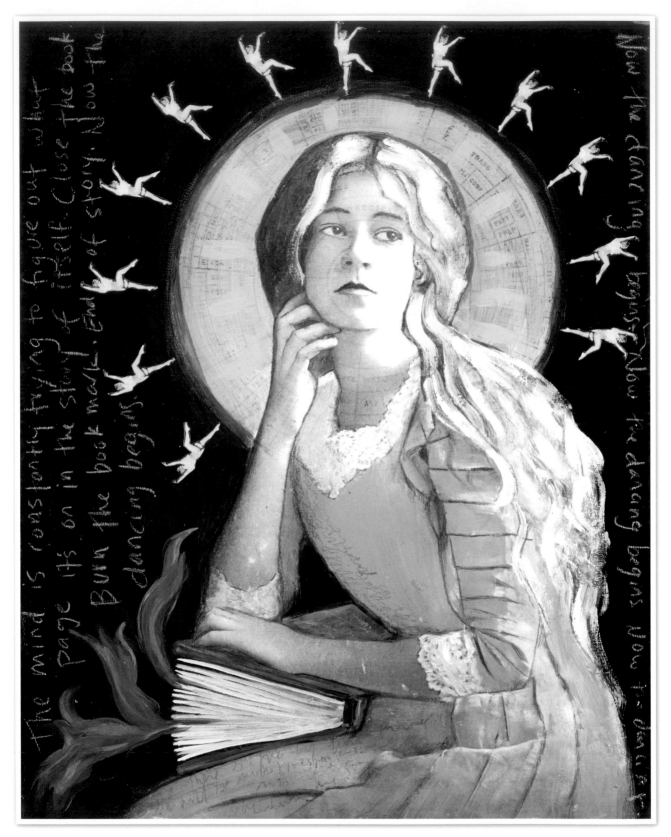

Now the Dancing Begins
9" × 12" (23cm × 30cm)
Acrylics, papers and images on cradled wood panel

Sign up for our free newsletter at CreateMixedMedia.com.

TRICIA SCOTT

The mind is constantly trying to figure out what page it's on in the story of itself. Close the book. Burn the bookmark. End of story. Now the dancing begins.

—Ikko Narasaki

What steps did you take to arrive at your concept for illustrating your chosen quote?

The first step was to sit with the quote and let the images come. It's a very visual quote and I had a hard time settling onto one idea. Once I had tossed around several possibilities in my head it was time to sketch a bit, to get the ideas onto paper. I knew that I wanted to show a woman who had closed the book and set fire to her bookmarks but who had only just begun to contemplate the next step, the dancing.

Briefly describe how you created the art.

The first step was to gesso a wooden panel. Then I transferred the vintage image of a woman. I added acrylic paints, graphite and Caran d'Ache Neocolor artist crayons along with the small cutout images of the dancers.

At what part of the process was the quote added to the piece?

The quote was the last thing added to the piece. I used a white Stabilo pencil. I had planned on just using it to help with the placement of the letters, intending to go back over with acrylic paint applied with a brush, but I liked how it looked as it was so I left it, spraying fixative to keep it all in place.

Do quotes play a regular part of your art or life?

Oh, that is a big yes! I have notebooks filled with quotes and have snippets of words and quotes taped up all over my studio wall. More inspiration is on those walls than I may ever have time to paint. I am also the same with song lyrics.

How do quotes inspire your everyday life?

Bad days have done a complete turnaround thanks to the right quote at the right time.

> *I want to think again of dangerous and noble things. I want to be light and frolicsome. I want to be improbable beautiful and afraid of nothing, as though I had wings.*
> —Mary Oliver

I recently had the last five words of the above quote—along with a pair of wings—tattooed on my ankle to celebrate news of my five-year cancer remission.

What one thing would you say most inspires your art?

A photograph, be it an old one from years and years ago or one taken of my daughter just for a specific painting idea.

Artist Bio

I'm a mixed-media artist, photographer and homeschooling mom. At the root of all of my work is story. There's a quote by Barry Lopez near my easel that reads: "If stories come to you, care for them. And learn to give them away where they are needed. Sometimes a person needs a story more than food to stay alive." I'm inspired by old photographs I find and by new photographs that I take, by myth and folklore, poetry and quotes.

www.tricia-scott.com

RESOURCES

The majority of products and materials mentioned in this book can be found at your local art, craft or paper store. For a list of harder-to-find items, go to: www.createmixedmedia.com/creativeletteringworkshop.

Additional Contributing Artists

Lois Parks DeCastro
www.afternoonarts.com

Pam Garrison
www.pamgarrison.com

Arlene Holtz
www.arleneholtz.com

Jenni Adkins Horne
www.jennihorne.com

Jennifer Joanou
www.jenniferjoanou.com

Mindy Lacefield
www.mindylacefieldart.com

Laura Taylor Mark
www.atailoredline.blogspot.com

Loretta Benedetto Marvel
www.artjournaler.typepad.com

Tiffin Mills
www.linwoodavenue.com

Roben-Marie Smith
www.robenmarie.com

Vicki Szamborski
www.vickiinyourhead.wordpress.com

Lynn Whipple
www.lynnwhipple.com

Digital Fonts and Image Sources

www.2ttf.com (iFontMaker for iPad)
www.deathtothestockphoto.com
www.designcuts.com
www.designerdigitals.com
www.eso.org
www.myfonts.com
www.unsplash.com
www.vintageprintable.com

Recommended Books by Lesley Riley

Create With Transfer Artist Paper by Lesley Riley

Creative Image Transfer: 16 New Mixed-Media Projects Using TAP Transfer Artist Paper by Lesley Riley

Inspirational Quotes Illustrated by Lesley Riley

Other Recommended Books

The Art of Whimsical Lettering by Joanne Sharpe

Creative Lettering and Beyond by Gabri Joy Kirkendall, Laura Lavender, Shauna Manwaring and Lynn Panczyszyn (Walter Foster)

Image Transfer Workshop: Mixed-Media Techniques for Successful Transfers by Darlene Olivia McElroy and Sandra Duran Wilson (North Light Books)

INDEX

DEDICATION

To my father, Leslie Hall Jackson, whose love, perpetually positive outlook and big old heavy book of *Bartlett's Familiar Quotations* started me down this road.

ACKNOWLEDGMENTS

It takes a lot of smarts, love and dedication to bring a book into the world. While most of the credit usually goes to the author, it's the behind-the-scenes team of talented professionals and contributing artists who made this book the art-filled handbook and resource you now hold in your hands. Special thanks go to my editor, Tonia Jenny, for trusting in my vision for this book; to Beth Erikson, my photo shoot editor, for keeping me calm and organized throughout the weeklong process; and to the always cheerful, highly skilled Christine Polomsky, photographer extraordinaire. This book passes through many skilled hands and eagle eyes before it ever makes it to the printer, and I want to acknowledge and thank each one of you for the attention to detail you gave to make it into something we all can be proud of.

I owe deep thanks and an even deeper expression of gratitude to the generosity of the seventeen artists who contributed their time and talent to enhance and multiply my vision. I love knowing that, inside these pages, each of you has shared a little piece of your heart and soul with us all.

Other fine North Light Books are available from your favorite bookstore, art supply store or online supplier. Visit our website at fwmedia.com.

19 18 17 16 15 5 4 3 2 1

fw

a content + ecommerce company

DISTRIBUTED IN CANADA BY FRASER DIRECT
100 Armstrong Avenue
Georgetown, ON, Canada L7G 5S4
Tel: (905) 877-4411

DISTRIBUTED IN THE U.K. AND EUROPE
BY F&W MEDIA INTERNATIONAL LTD
Brunel House, Forde Close, Newton Abbot, TQ12 4PU, UK
Tel: (+44) 1626 323200, Fax: (+44) 1626 323319
Email: enquiries@fwmedia.com

DISTRIBUTED IN AUSTRALIA BY CAPRICORN LINK
P.O. Box 704, S. Windsor NSW, 2756 Australia
Tel: (02) 4560-1600; Fax: (02) 4577 5288
Email: books@capricornlink.com.au

ISBN 13: 978-1-4403-4079-6

Edited by Tonia Jenny
Cover designed by Laura Kagemann
Interior designed by Laura Spencer
Production coordinated by Jennifer Bass

METRIC CONVERSION CHART

To convert	to	multiply by
Inches	Centimeters	2.54
Centimeters	Inches	0.4
Feet	Centimeters	30.5
Centimeters	Feet	0.03
Yards	Meters	0.9
Meters	Yards	1.1

ABOUT LESLEY

Lesley Riley wears many hats. She is an internationally known artist, art quilter, teacher, writer and Artist Success coach and mentor who turned her initial passion for photos, color and the written word into a dream occupassion.

Her art and articles have appeared in too many places to keep count. As former contributing editor of *Cloth Paper Scissors* magazine, Lesley developed a passion for showcasing new talent in mixed-media art, now evidenced in this book you hold in your hands.

Lesley's first book, *Quilted Memories,* brought new ideas and techniques to quilting and preserving memories. A second, *Fabric Memory Books,* combined fabric and innovative ideas with the art of bookmaking. Two more books, *Fabulous Fabric Art With Lutradur* and *Create With Transfer Artist Paper,* introduced versatile new materials to the mixed-media art world and led to a fifth book in 2014, *Creative Image Transfer.*

In an ongoing effort to find the best ways for quilters and mixed-media artists to get permanent photos on fabric, Lesley introduced Transfer Artist Paper™, named the Craft & Hobby Association 2011 Most Innovative new product, the state of the art technology for iron-on transfers.

Lesley is the former host of BlogTalk Radio's *Art & Soul* show, recording over seventy-five podcasts on art and the creative process through in-depth interviews with contemporary artists. Her passion and desire to help every artist reach their creative dreams and potential has led to a growing specialty as an Artist Success coach and mentor where she draws from her own experience, insight and a knack for seeing the potential in everyone to provide guidance and solutions for artists of all levels.

Lesley creates her magic in Frederick, Maryland, where she lives with her high-school sweetheart husband and one of her six children. You'll find her in her studio from sunup to sundown unless, of course, any of her eight grandchildren come to visit.

Stay connected and inspired! Sign up for Lesley's free biweekly dose of inspiration and motivation at www.lesleyriley.com.

IDEAS. INSTRUCTION. INSPIRATION.

Receive FREE downloadable bonus materials when you sign up for our free newsletter at CreateMixedMedia.com.

Find the latest issues of Cloth Paper Scissors on newsstands, or visit ClothPaperScissors.com.

 These and other fine North Light products are available at your favorite art & craft retailer, bookstore or online supplier. Visit our website at CreateMixedMedia.com

 Follow CreateMixedMedia.com for the latest news, free wallpapers, free demos and chances to win FREE BOOKS!

Get your art in print!

Visit **CreateMixedMedia.com** for up-to-date information on *Incite* and other North Light competitions.